LITERARY SUSSEX

Alan Starr

AMBERLEY

Acknowledgements

Thanks are due to Geoffrey Barber, Lynn Gausden, Alex Gingell, Nic Howell, Scott McCracken, Jean Farebrother, Jane Murray Flutter, David Page, Jennifer Parsons, Steve Peak, David Tye, Dee Walker, Tom Wareham and Alan Wenham.

The author and publisher would like to thank the Dorothy Richardson Literary Estate for permission to use copyright material from Dimple Hill, 1938.

First published 2021

Amberley Publishing
The Hill, Stroud
Gloucestershire, GL5 4EP

www.amberley-books.com

Copyright © Alan Starr, 2021

The right of Alan Starr to be identified as the Author of this work has been asserted in accordance with the Copyrights, Designs and Patents Act 1988.

ISBN 978 1 3981 0004 6 (print)
ISBN 978 1 3981 0005 3 (ebook)

British Library Cataloguing in Publication Data.
A catalogue record for this book is available from the British Library.

Typesetting by SJmagic DESIGN SERVICES, India.
Printed in Great Britain.

Contents

Introduction

There were few Sussex writers before the nineteenth century, mainly because there were so few Sussex people. There was rich farmland here, but it was cut off from London by the high ground in the north of the county. To the south, the coastline was always shifting and there was no large port. Employment was available for shepherds, fishermen and ox drivers. As late as 1749, Horace Walpole was telling a friend 'never go into Sussex ... the whole country has a Saxon air and the inhabitants are savage'.[1]

In those days, the few writers who were born in Sussex left fairly quickly. John Fletcher, the Jacobean dramatist, was born in Rye but was at Cambridge by the age of eleven. Thomas Paine and John Evelyn both lived in Lewes for a short time, but wrote nothing of significance before they departed. Percy Shelley was born at Field Place, near Horsham, but did not stay.

Rottingdean, the home of Rudyard Kipling and Enid Bagnold.

This changed when road transport improved. In the late eighteenth century Sussex began to draw writers to its coastal resorts. In time the very wildness that repelled Walpole became a positive attraction. A love of nature and a love of the nation were closely intertwined, so the 'Saxon' air of the county became especially invigorating. The place names of Sussex are overwhelmingly Anglo-Saxon and have kept their names for well over a thousand years. Sussex came to stand for the real England, especially when its white cliffs were defending the island. Hilaire Belloc was conscious of this, and in the Second World War propaganda wartime posters presented Sussex scenes as an idyllic England.

Some writers came to Sussex almost by accident. D. H. Lawrence stayed at Greatham for a few months in 1915 and completed *The Rainbow* there; he could easily have been in Cornwall, or anywhere that offered free accommodation and silence. There were also, inevitably, writers who visited the fashionable coastal resorts. Oscar Wilde created *The Importance of Being Earnest* in Worthing. There is a residue of this event in the play itself (the character Jack Worthing) and a blue plaque not too far from his Worthing house. Some, like Thomas Carlyle, sought the health benefits of the seaside. Other writers had small places in Sussex, which they could visit at the weekends: Martina Cole acquired a caravan in Pevensey Bay.

Ashdown Forest.

Hastings Beach.

The emphasis in this book is on writers who have written about the county, rather than writers who have simply visited, or who have been born here. The book is ordered geographically, starting in the far west of the county and moving eastwards. The coverage will necessarily be uneven. Some towns seem to have left no literary mark, and do not feature in the book. On the other hand, there are small areas where the writers clustered: a single house in Rye was occupied, at different times, by E. F. Benson, Rumer Godden and Henry James.

Chapter one looks at the far south-west of the county and the development of Bognor Regis. The main writers here are William Blake and Jane Austen, plus William Hayley and Charlotte Smith.

Chapter two covers the area from Chichester to Arundel: Charlotte Smith and Hilaire Belloc plus John Keats, Kate Mosse, Mervyn Peake, John Cowper Powys and Rosemary Sutcliff.

Chapter three is about Brighton and its raffish reputation: Graham Greene's *Brighton Rock*, plus Fanny Burney, Ivy Compton-Burnett, Enid Bagnold, Julie Burchill, Patrick Hamilton, Peter James, Keith Waterhouse, Lynne Truss and Helen Zahavi.

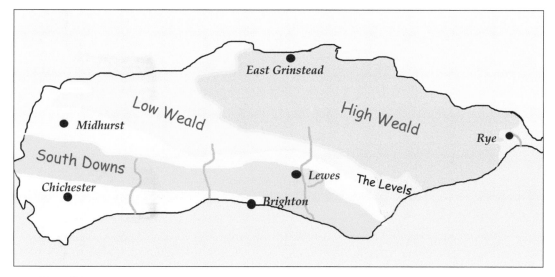

Map of Sussex.

Chapter four looks at the rich men who settled in the rich soils north of the Downs: John Galsworthy, Alfred Tennyson and, among the servants, H. G. Wells.

Chapter five shows the development of the coast from Eastbourne to Hastings. Here are, perhaps surprisingly, a group of socialists, beginning with Friedrich Engels and George Meek, then moving on to Robert Tressell via David Hare and George Orwell. There are also works by Sheila Kaye-Smith, Lewis Carroll, T. H. Huxley and Rider Haggard.

Chapter six looks to the area between Lewes and the sea. Virginia and Leonard Woolf are here, with the rest of Bloomsbury, plus Dirk Bogarde, Eleanor Farjeon and Malcom Lowry.

Chapter seven is set in the far south-eastern end of the county, in Rye and Winchelsea. Henry James is the major figure, along with Joseph Conrad, Ford Madox Ford, Rumer Godden, Radclyffe Hall, Conrad Aiken, Stephen Crane and E. F. Benson.

Chapter eight explores the east of the county, with Rudyard Kipling at Burwash and Sheila Kaye-Smith in Peasmarsh. There are also appearances from W. B. Yeats, Ezra Pound, Dorothy Richardson, Richard Jefferies and A. A. Milne.

We deal with around sixty writers, and none of them can be given as much attention as they deserve.

1. Visions of Albion – from Felpham to Sanditon

Felpham

> He set me down in Felpham's Vale & prepar'd a beautiful
> Cottage for me, that in three years I might write all these Visions,
> To display Nature's cruel holiness: the deceits of Natural Religion.
>
> *Milton*, William Blake

Two hundred years ago there were very few dwellings anywhere along the Sussex coast, but the village of Felpham, south of Chichester, had a mansion, a large Gothic-style house known as The Turret. This was home to William Hayley (1745–1820), a gentleman of letters 'by the grace of the public, king of the bards of Britain'.[1] His best-selling poem 'The Triumphs of Temper' (1781) went through eighteen editions. In 1790 he was invited to be Poet Laureate but turned the invitation down (in verse).

Hayley dropped out of fashion before he died, and his name would be forgotten but for an act of generosity. In 1800, he invited the hard-up William Blake (1757–1827) to leave London and stay near him on the coast. William Blake was known to Hayley as a skilful engraver, and as a lower-class man with truly eccentric notions. Hayley did not like the notions, but wanted the artist to develop his skills. He commissioned engravings from Blake and introduced him to upper-class clients.

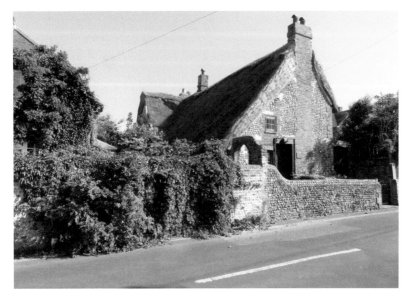

Blake's cottage in Felpham.

A cottage was rented from the landlord of Felpham's Fox Inn at the cost of £20 a year. The high price reflected Felpham's growing desirability: cottages which used to rent for £5 were being gentrified, with whitewash on the outside walls and carpets on the stairs.

> Felpham is a sweet place for Study, because it is more Spiritual than London ... voices of Celestial inhabitants are more distinctly heard, & their forms more distinctly seen...[2]

William and Catherine Blake left London early on the morning of 18 September 1800. They arrived in Felpham shortly before midnight. There had been seven changes of coach, made more difficult by the large amount of luggage that Blake and his wife had to transport. They were not only moving home but moving their workplace as well – they were loaded down with engraving plates and equipment. The Blakes – either from necessity or principle – did not have a servant.

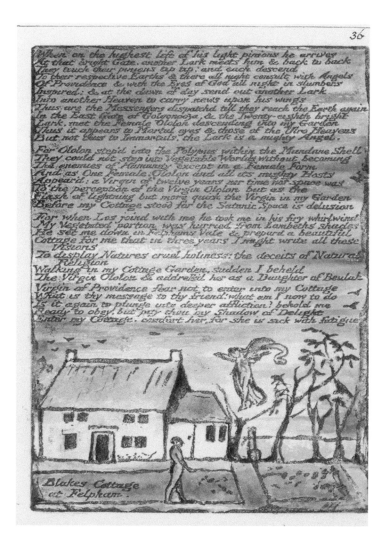

Cottage by Blake.
(The New York
Public Library Digital
Collections)

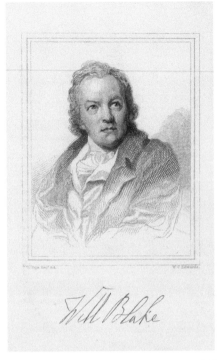 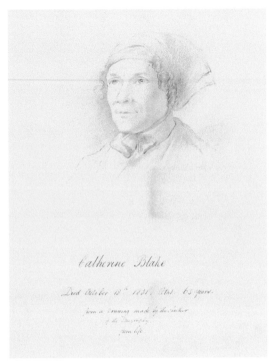

Above left: *William Blake after Thomas Phillips.* (Yale Center for British Art, Paul Mellon Collection)

Above right: *Catherine Blake after Frederick Tatham.* (Yale Center for British Art, Paul Mellon Collection)

The couple arrived in Felpham with sixteen heavy boxes and artwork. William also brought a full mind. 'In my Brain are studies & Chambers fill'd with books & pictures of old, which I wrote & painted in ages of Eternity before my mortal life; & those works are the delight & Study of Archangels.'[3]. This was not a piece of literary exaggeration; Blake believed this as the literal truth. He was from a tradition of radical dissent and in London he mixed with mystical visionaries: followers of Joanna Southcott, theosophists and the Swedenborgians with their New Jerusalem Church. All of them were convinced that the material world was just a shadow or a flimsy veil: the true and eternal world was only understood through the visionary imagination. Many were sure that the veil would soon be ripped open by a burst of revolutionary, apocalyptic flame.

For the Blakes – as for generations of Londoners – a stay on the Sussex coast was the first encounter with deep countryside, silence and the sea. In addition, Hayley was a well-read man and a literary biographer of Milton. In the library at The Turret, Blake was able to learn Greek and Latin.

Of course, life in the country had its drawbacks. Catherine contracted the ague from the damp in the cottage, and William caught a cold. The spirits, however, kept visiting. Blake was able to see a fairy funeral in his garden.

As his time in Felpham was coming to an end, Blake had an argument with John Scofield, a private in the dragoons who was staying up the road at the Fox Inn. Blake was

Felpham's vale.

not favourable to soldiers or the king they served. There was an altercation and Blake found himself on trial in Chichester for sedition. His benefactor, Hayley, provided a legal defence showing that Blake was a perfectly loyal subject of the king: quite untrue, but Blake was nevertheless acquitted by the Chichester jurors.

In later years Blake built upon his time in Felpham. While in Felpham he wrote a large amount of poetry, or possibly it was dictated by higher powers. When the Blakes returned to London, these verses emerged in the epics which he printed and published from 1804 onwards. The first of these, *Milton*, shows Christ walking through the fields of Albion.

> Jesus wept, & walked forth
> From Felpham's Vale clothed in Clouds of blood, to enter into
> Albion's Bosom

The frontispiece of *Milton* dwells on this idea, in verses which have become the English national anthem:

> And did those feet in ancient time
> Walk upon England's mountains green?

This is the hymn that we now call 'Jerusalem', and it was born in Felpham. England does not have many mountains as we now understand the word, but in the eighteenth century Gilbert White described the South Downs as 'that chain of majestic mountains'.[4] Blake walked close to these hills one day at the end of 1801. He was crossing over the fields

towards Lavant where his sister was due on the London coach when he experienced an intense vision.

> Los flam'd in my path, & the Sun was hot
> With the bows of my Mind & the Arrows of Thought
> My bowstring fierce with Ardour breathes,
> My arrows glow in their golden sheaves;[5]

In 1804, back in London, he began to engrave the words that had been dictated to him in Felpham, commencing with the frontispiece of *Milton*:

> Bring me my bow of burning gold!
> Bring me my arrows of desire!
> Bring me my spear! O clouds, unfold!
> Bring me my chariot of fire!

Bognor, Worthing and Sanditon

Felpham is now mainly a post-war suburbia that merges into the resort town of Bognor Regis. Parts of Blake's Felpham remain: The Fox Inn and Blake's cottage are still standing. From the cottage, a pleasant and leafy 1930s road leads the few hundred yards down to the sea. The main local landmark is half a mile from the village: the Butlins Bognor Resort. Billy Butlin set up a holiday camp in the 1930s despite fierce opposition from the Felpham Ratepayers. This process was already under way when Blake stayed there. Blake does not mention it, but the beach at Felpham was already being set to work. In 1807, we read,

> Felpham was frequented by persons who sought a maritime residence in summer, long before Bognor was brought into notice: and those who may choose to make it their abode, will find a sandy beach, well-adapted for bathing, four or five machines, and several lodging houses of many dimensions.[6]

While the Blakes envisaged the golden gates of Heaven, others saw gold of a simpler type. The arrival of Londoners meant a rich opportunity to transform the sleepy villages into bustling watering places. A simple strategy was repeated all along the Sussex coast. First of all, find a small town, like 'Bright Helmston', which in 1724 Daniel Defoe described as 'a poor fishing town, old built on the very edge of the sea'. Then you must advertise the quality of waters and the air, build some elegant buildings, and ensure that there is a library. A seawall might be called for. Above all, persuade eminent people to stay in the new resort, and they will attract the mass of middling people. Ideally, you would attract royalty, as Brighton was able to do. Failing that, lords and ladies could be encouraged to visit. Charlotte Smith describes a lady staying in Brighton, happy that she has 'added five titled friends to her visiting list for the ensuing winter'.[7] Even a radical reformer could help if she was famous enough. When the Quaker abolitionist (and very beautiful) author Amelia Opie (1769–1853) spent the summer at Hayley's house in Felpham, the devout were encouraged to visit Bognor, just a mile to the west.[8]

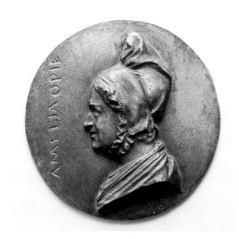

Right: Amelia Opie by David Angers.
(Yale Center for British Art)

Below: Bognor in the 1900s.

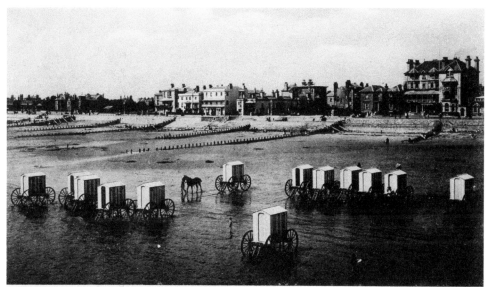

The Sands and Esplanade (West of Pier), Bognor W. P. Marsh, Photo, Bognor

In 1784 Bognor – yet another fishing village – had caught the eye of Sir Richard Hotham (1722–99). He was an old man – sixty-two years of age– and had come to the sea for his health. He was also restless. Hotham bought 1600 acres of land, built fine houses and a crescent on the model of Bath, and named the new area after himself: Hothampton.

He had begun life as a hatter and was also a hosier (like Blake's father). He was a clever advertiser and had thin copper disks printed with his shop address on either side, which would fit easily into a pocket or purse. He moved on to East India shipping, and by his industry he became a very rich man and an MP. Then he threw himself (and most of his fortune) into Bognor. He wished – like so many resort developers – to build a quiet, exclusive and highly prestigious watering place. It began well enough as a fashionable venture.

In 1795 he attracted the Speaker and the Duke of Devonshire. One house was set aside for the king to stay in, but sadly the monarch could not be persuaded to abandon Weymouth.

Financially, the venture was ruinous and Hotham's career is parodied in T. S. Surr's 1815 novel *The Magic of Wealth*. In the novel, a draper in a market town sends his little son off to London as an apprentice. When he returns, the little boy is sat at a counter in the shop with a pencil on his ear and a sign above his head saying 'The Bank'. The shop acquires a new name 'Flim-Flam and Son, Bankers'. In no time at all the young boy becomes Francis Flim-Flam Esq, and is creating a new watering place, to be called Flimflamton. He judiciously extends loans to fashionable aristocrats, who are obliged to visit Flimflamton and its splendid Grand Pavilion Library. Flim-Flam's career ends in a well-deserved bankruptcy – even two hundred years ago people were appalled at the bankers' ability to create money.

Sir Richard Hotham was, by all accounts, endlessly optimistic about Hothampton, even as his project faltered. By 1805 the resort was in a poor way. There was a subscription room, but the library did not loan books.

Visitors needed a strong incentive to visit a resort, because the journey from London could be arduous. In Charlotte Smith's novel *The Young Philosopher* (1798), we see a wealthy clergyman and his family attempt to take their coaches across the downland from Brighton. They are soon lost in the fog and thunder, and as evening encroaches, the

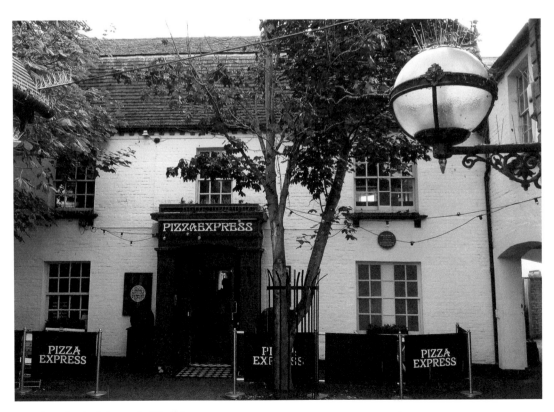

Jane Austen's house in Worthing.

Sussex countryside becomes menacing. Some of the horses bolt, and a young woman in the party is thrown out, losing consciousness and breaking her arm.

One keen reader of Charlotte Smith was Jane Austen (1775–1817), who began *Sanditon* (1817) with a similar episode. The story opens somewhere near Eastbourne, where a Mr Parker and his family find themselves on a very poor road. There is an accident with the carriage, and Mr Parker must spend some time in the countryside. Mr Parker has strayed from the beaten track because he is looking for a doctor. Not that he is ill, but he is seeking a surgeon who might come and live in the new seaside resort of Sanditon. Sanditon – as the name suggests – has a sandy beach, and is in all ways excellent for the health, but the lack of a resident doctor is putting people off. Austen understands the minds of the resort builders. Like Hotham, Parker is obsessed and always optimistic.

> Sanditon—the success of Sanditon as a small, fashionable bathing place, was the object for which he seemed to live ... Mr. Parker could now think of very little besides.[9]

Parker will grasp at any available straw:

> 'The most desirable distance from London! One complete, measured mile nearer than Eastbourne. Only conceive, sir, the advantage of saving a whole mile in a long journey.'[10]

Jane Austen visited Worthing in 1805, when the resort was undergoing rapid development. It has been suggested that Worthing is the model for her unfinished novel. Austen was twenty-nine at the time and had yet to publish. She arrived on 18 September 1805, in a family group that included her sister Cassandra. The family stayed at Stanford Cottage, which is still in existence and is currently used as a Pizza Express restaurant. Worthing at this point had thirty bathing machines; most importantly, it had received royal approval in 1798, when Princess Amelia stayed there for six months. It had a large library and elegant crescents.

The driving force was Edward Ogle, a man who had – with his brother – made his money from the sugar trade in London. Ogle came from the north of England, and his father was probably a hatter. The brothers became important figures in the London docks. Edward bought land in Worthing and was soon involved in civil engineering projects to make the town suitable for a large population, and he built lodging houses. We know that Jane Austen met a Mr Ogle in London in 1813, but there were at least four Mr Ogles in London society at the time. We can be sure that Austen will have observed Worthing closely, and have seen a town much larger than the fictional Sanditon.

Sanditon is struggling. Mr Parker is a benign figure 'generally kind-hearted; liberal, gentlemanlike, easy to please', a landowner who lacks the drive of a Flim-Flam or a Hotham. His resort is modest. He has no hopes of attracting the king, but expects that solid people will come to Sanditon. Under Austen's withering gaze, the pathos of the place is clear.

> The shops were deserted. The straw hats and pendant lace seemed left to their fate both within the house and without, and Mrs. Whitby at the library was sitting in her inner room, reading one of her own novels for want of employment. The list of subscribers was but commonplace.[11]

This might be Bognor at a low ebb, or even the desperately unfashionable resort of Littlehampton. A sniffy guide noted that Littlehampton 'is certainly well adapted for family parties, whose enjoyments begin and end in their own circles'.[12] As the coast was developed, there proved to be many more Littlehamptons.

Lancing, looking towards Brighton.

2. The South Country – Chichester to Arundel

Bignor

Charlotte Turner Smith (1749–1806) spent much of her childhood at the family home of Bignor Park, near Chichester. She was a bookish child, but was allowed to go into the Sussex countryside and to play beside the River Arun.

> Farewell, Aruna! On whose varied shore
> My early vows were paid to Nature's shrine
> When thoughtless joy and infant hopes were mine
> > 'Sonnet XLV', Charlotte Smith

These were the same places, she later noted, that had been home to the dramatist Thomas Otway (1652–85). Her childhood happiness ended abruptly when she was fifteen and her

View Near Arundel, Sussex by George Smith. (Yale Center for British Art, Paul Mellon Collection)

family manoeuvred her into a hateful marriage. Her husband was Benjamin Smith, the son of a West India merchant. She described him as a monster and said that her father had sold her into legal prostitution.

Her in-laws were coarse and materialistic, living in a smoky street close to the London docks and despising Charlotte's education. The Smiths were concerned that their son Benjamin was too wild and marriage to Charlotte was intended to tame him. It did not, and her life of misery began. Her Sussex childhood became a lost paradise.

> I once was happy, when while yet a child
> I learned to love these upland solitudes.
>
> Charlotte Smith, 'Beachy Head'

The physical jolt of living in London was the least of her problems. The major one was her intemperate, unfaithful and abusive husband. To make matters worse, all of this was the decision of Charlotte's family. It is like the plot of an old novel. Her father, Nicholas Turner, needed to marry an heiress, and the heiress refused to live in the same house as his contrary daughter. An interfering aunt made the necessary arrangements for the fifteen-year-old to marry. None of this should have been necessary. When Nicholas Turner inherited the estate in 1747 – along with land in Surrey and a number of other properties – he inherited a very secure income. The farmland north of the Downs has long been the site of wealthy landlords. The soil – 'rich and stiff loam' said the agronomist Arthur Young in 1813 –has offered dependable income over the centuries. Bignor is now best known for the mosaic floor of a Roman villa; even in AD 350 there was a wealthy man living here.

Unfortunately Nicholas had a gambling habit and his daughter was condemned to a life of abuse and degradation. Charlotte had twelve children by Smith, who sank steadily into bankruptcy. In December 1783, she voluntarily followed her husband into a debtor's prison, a wretched place. At one point, the inmates were planning to blow a hole in the prison walls. While she was in the gaol she left her children with her brother in Sussex and attempted to negotiate with her husband's creditors.

At this time she was writing a collection of poems that were published under the title *Elegiac Sonnets*. The publication was achieved with the help of William Hayley, Blakes's benefactor, and it was a success. In time she became a professional author, but there was no happy ending.

She was always a revolutionary and a vigorous defender of women's rights. She supported the French Revolution in its early days, and lived for some time in Brighton, a hotbed of radicalism. Revolutionary sentiments were not thought becoming in a lady. When financial pressure made her a novelist – a very successful one to begin with – her fiction was radical and autobiographical. It was also rather depressing, which made her less popular as the years went on. Eventually her money and her health gave out and she became destitute before she died in 1806. Charlotte always kept her links with Sussex and (to keep her status as a gentlewoman) styled herself 'Charlotte Smith of Bignor Park'. The current house at Bignor, incidentally, dates from 1826 and is not the one which Charlotte knew.

Elegiac Sonnets was dedicated to William Hayley, who lived a few miles away at Eartham. The sonnets in the collection were often local and autobiographical. She would

John Constable, *A View near Petworth*. (Yale Center for British Art, Paul Mellon Collection)

begin with a description of a specific place she had been, sometimes giving the date of the visit. The location would prompt thoughts and feelings. One of these poems was about the church at Middleton where the sea was, as always, eroding the Sussex coast. The graveyard was going under the water, and human bones could be found in the shingle beach.

> Lo! their bones whiten in the frequent wave;
> But vain to them the winds and waters rave;
> They hear the warring elements no more:
> While I am doomed, by life's long storm oppressed,
> To gaze with envy on their gloomy rest.
>
> 'Sonnet XLIV', Charlotte Smith

Today this is a tired and traditional way to write nature poetry, but in 1784, the combination of the natural, the reflective and the personal was extraordinary. Charlotte also loosened the sonnet form, making a sonnet much quicker to construct.

She always wished to be thought of as a poet, but sadly her poetic reputation did not survive. This was in part because she had many followers, and one of them was William Wordsworth (1770–1850). He acquired his own copy of *Elegiac Sonnets* in 1789. In 1791, when he was twenty-one years old, he visited Charlotte in radical Brighton. He was on his way to revolutionary Paris, and Charlotte provided him with letters of introduction. Wordsworth's reputation began to grow, and – pacing through the Lake District rather than Sussex – he became the autobiographical nature poet of the new century.

On Christmas Eve 1802, Dorothy Wordsworth was sitting with her brother, who had a chest problem, while he was leafing through Charlotte Smith's sonnets.

Charlotte famously published poems about herself at a specific place and time: 'Sonnet XXXI. Written on Farm Wood, South Downs, May, 1784'. Wordsworth went a few steps further: 'Lines Composed a Few Miles above Tintern Abbey, On Revisiting the Banks of the Wye during a Tour. July 13, 1798'. Wordsworth replaced Charlotte's melancholy with an elevated Romantic sublimity. Sometimes you can detect her words and phrases. In *Elegiac Sonnets*, the natural world is cold and inhuman. Wordsworth is much more uplifting, and echoes of Charlotte's verse were transformed into some of the best-known lines in English poetry. Charlotte glooms over 'sullen surges and the viewless wind' while William says that 'Visionary power/Attends the motions of the viewless winds'. Charlotte's words can be reassembled in a kind of alchemy:

> While thy low murmurs sooth'd his pensive ear,
> And still the poet consecrates the stream.
>> 'Sonnet XXVI', Charlotte Smiith

> The light that never was on sea or land,
> The consecration, and the Poet's dream.
>> 'Sonnet CCLXXVI', William Wordsworth

The path to Halnaker Mill.

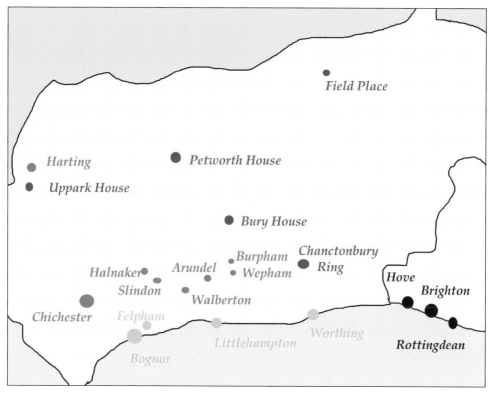

Map of West Sussex.

The disciple outshone the teacher and Charlotte Smith sank into the footnotes of literary history. The two poems, which survive as anthology pieces, 'Middleton Church' and 'Beachy Head' are both Sussex poems.

Chichester and Arundel

This part of Sussex has rich farmland and beautiful scenery. It also has two historic towns in Chichester and Arundel. Each has a cathedral, and Arundel has a fairy tale castle.

John Keats visited Chichester for a few days in January 1819. We read Keats now because of the poems he wrote in that year, the first of them being 'The Eve of St Agnes'. That festival is on 20 January, when the young poet was certainly in the city. The city has now erected a Keats statue to mark the brief association. We know that Keats took a letter from his new love Fanny Brawne to the cathedral (to read in private) and the medieval building provided some source material for the Gothic architecture in the poem:

> Along the chapel aisle by slow degrees:
> The sculptur'd dead, on each side, seem to freeze,
> Emprison'd in black, purgatorial rails:
> Knights, ladies, praying in dumb orat'ries
>
> 'The Eve of Saint Agnes', John Keats

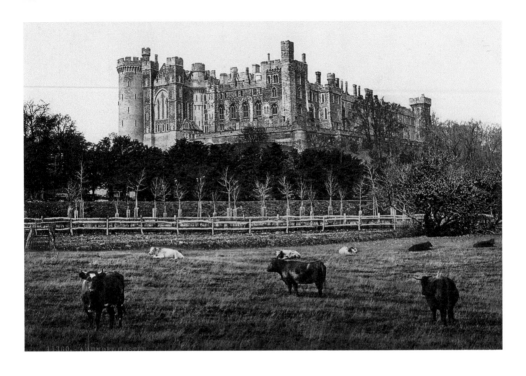

Above: Arundel Castle in the 1890s. (Library of Congress)

Left: Chichester Cathedral.

Above: Keats' house in Chichester.

Right: Keats' statue in Chichester.

There was an important poetic moment early in 1954, when Philip Larkin visited the cathedral. Like Keats, he saw the sculptured dead, especially the tomb of Richard Fitzalan, 13th Earl of Arundel. The tomb also commemorates his wife Eleanor, and the two stone statues lie together, holding one another's hands. The result was one of Larkin's best loved

View towards Arundel Castle from Wepham.

poems: 'An Arundel Tomb'. Chichester's native poet is William Collins, who was well regarded in the age of James Thomson, but is rarely read today. He had some success as a poet, but was committed to a madhouse in his early thirties.

History and the mysterious sit easily in this part of the world. In the village of Wepham, the novelist Mervyn Peake could gaze out from his room and look across the water-meadows to Arundel Castle while writing about Titus Groan and Castle Gormenghast. This is continuing today, as Chichester has also been home to Kate Mosse (b. 1961). She is the author of the international best-sellers in the Langedoc trilogy: the first is Labyrinth, where real historical events from medieval France intertwine with a present-day plot, at the heart of it all is the holy grail. Mosse has been loyal to Chichester and also written about Sussex: *Why the Yew Loves So Long* is a mystical short story about Kingley Vale, just north of Chichester. A few miles south-west of the city is the village of Walberton, where the children's novelist Rosemary Sutcliffe lived.

John Cowper Powys lived at Burpham from 1902 to 1929. He produced little of literary value here, but in time became one of the great mystical novelists. In the semi-autobiographical novel *After My Fashion*, he describes a fictional character arriving in Sussex after living in France. In the countryside around Chichester he sees the Downs in the mist, and luxuriates in the thought that he is back among the English.

Right: Kate Mosse. (Ruth Crafer)

Below: Near Arundel.

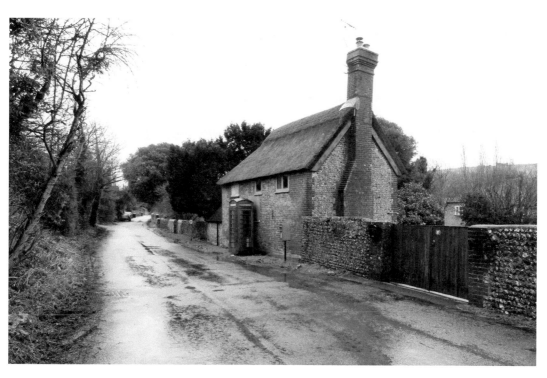

Halnaker Mill

One of the highest points in this part of the world is Halnaker Hill, a Neolithic causewayed enclosure. It has a windmill on top, and spectacular panoramic views; a nearby track through the fields is a vestige of the Roman Stane Street. The mill was owned at one point by Hilaire Belloc. Belloc (1870–1953) was born in France but was brought up in Slindon, just 4 miles south of Charlotte Smith's Bignor.

Belloc spent most of his boyhood in Slindon. He became an MP and was an astonishingly prolific writer. He is best known today for his *Cautionary Tales for Children*, including the tale of 'Matilda Who told Lies and was Burned to Death'. In his day he was highly regarded as a social thinker. He proposed the widest possible individual ownership of property opposing the concentration of ownership envisaged by capitalists and socialists. The author of *The Servile State* was Catholic and conservative, with a strong dislike of Prussian militarism, secularism, Jewish financiers and female suffrage. In the wilds of Sussex, hidden from the modern world, Belloc saw a kind of Eden. His poem 'The South Country' places Sussex as the glory of England.

The Four Men (1911) shows Belloc walking across the county. There are, as the title suggests, four men travelling together, but they are all aspects of Belloc himself. The journey begins on 29 October 1902 at The George Inn in Robertsbridge. Five days later the men arrive in Harting in West Sussex. They avoid the modern towns and relish the traditional Sussex of the Weald and the small towns. Belloc was in love with an

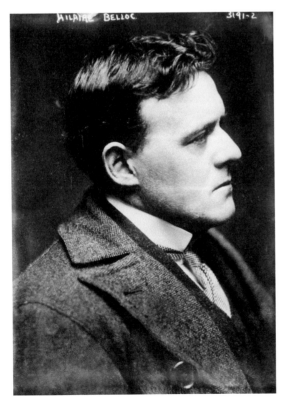

Hilaire Belloc. (Library of Congress Prints and Photographs Division)

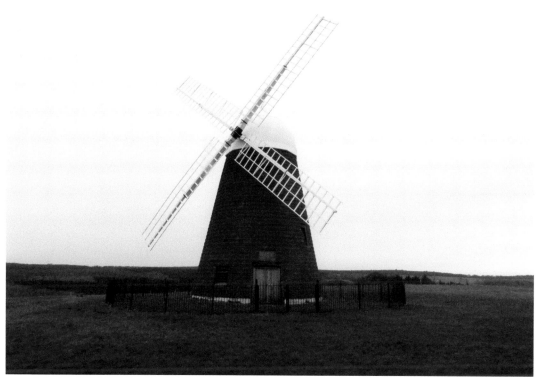

Halnaker Mill.

old Sussex. In *The Four Men* he is looking back ten years and already is looking at a world which is being lost. Sussex, like all things, must decay, and its end may be close: 'one will passionately set down one's own horizon and one's fields before they are forgotten and have become a different thing'.[1]

Sussex was already becoming a different thing. Horsham had for centuries – since it was settled by the Anglo-Saxons – been pronounced 'Horse-ham'. In the twentieth century, as new people arrived from London, they adopted the pronunciation suggested by the spelling – 'Horsh-am'. Sussex singing was known in the old days for its strange, high-pitched nasal delivery and an indifference to ordinary notions of tonality and metre. The county provided rich pickings for the folk-song collectors but when they were published the songs conformed to contemporary ideas of melody. Belloc was a lover of Sussex songs, and the county has retained a folk-song tradition, partly through the Copper family of Rottingdean and Shirley Collins from Hastings.

For Belloc, his beloved Sussex could easily stand for the whole of English society. In Belloc's day, Halnaker windmill had been struck by lightning and fallen into disuse and the poet saw in this the wider decline of the modern economy: 'Ha'nacker's down and England's done.'[2] Today the mill has been restored but on a still day you can hear the drone of traffic on the A27.

Belloc is remembered by some Sussex patriots on 'Belloc night', 27 July. It is fair to say that this does not quite match the popular enthusiasm for Burns Night in Scotland.

If there is a Sussex anthem it is 'Sussex by the Sea', published in 1907 by William Ward-Higgs (1866–1936). It takes its title (probably) from a Rudyard Kipling verse, and has become the anthem of Brighton and Hove Albion FC:

> For we're the men from Sussex, Sussex by the Sea.
> We plough and sow and reap and mow,
> And useful men are we;
> And when you go to Sussex, whoever you may be,
> You may tell them all that we stand or fall
> For Sussex by the Sea!

Ward-Higgs was not himself from Sussex and did not personally plough or reap or sow. He was a barrister born in Birkenhead and lived for a few years in Bognor Regis. Bognor is a town that does not feature much in Belloc's view of Sussex. His map for *The Four Men* is based upon Roman Britain and shows a few coastal resorts.

There is a tension between the rural Sussex that people write about and the coastal Sussex where so many of them live. Gladys Mitchell catches this in her 1934 story *Death at the Opera*. The main character (or at any rate, the murder victim) heads off for a holiday to Bognor Regis. She will, however, take plenty of bus trips to visit the Kipling country and the Sheila Kaye-Smith country, which she can talk about intelligently on her return.

Cressida Connelly's 2017 novel *After the Party* sets out the history of Sussex in a few dwellings. In the background of the novel there are the tents used by the British Union of Fascists for their summer camp at Selsey. The main character starts off in the family house, The Grange, a place where history seems to have stopped. Then she rents a charming house by the old harbour of Bosham. As decline begins in the 1930s, her husband wishes to build a new home with a tennis court in a treeless patch of development land. Finally, as complete humiliation looms, they consider moving to a Victorian villa in Worthing.

3. Helping the Police with Their Inquiries – Brighton and Hove

In Jane Austen's *Pride and Prejudice* (1813), the mild Mr Bennett has a moment of intransigence: 'You go to Brighton. I would not trust you so near it as Eastbourne for fifty pounds!' The town has had an image problem for a very long time, with its frivolity, adultery and decay, plus a strong undertow of violent crime. Writers have loved it, of course.

For most of its existence, Brighthelmstone was a coastal village, making an earnest living from fishing and smuggling. When sea bathing became the fashion in the eighteenth century, the village turned into a glamorous watering place like Bath, but much closer to London. Bognor and Worthing struggled to find aristocratic patrons, but Brighthelmstone caught the eye of the Prince Regent. He would race down from London to escape prying eyes and spend time there with Maria Fitzherbert. He even commissioned a residence there, John Nash's flamboyant Royal Pavilion of 1823.

We can catch a hint of the town's atmosphere from Fanny Burney (1752–1840). She visited in 1779 to flirt and observe. One day she came across a company of the Sussex Militia being

Brighton from The Old Ship Hotel.

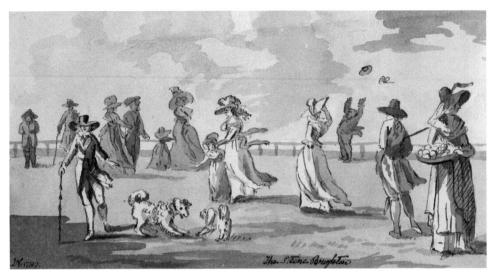

The Steine, Brighton by John Nixon. (Yale Center for British Art, Mellon Collection)

drilled by Captain Jack Fuller. Only twenty-two years of age, he was a very rich young man from the Sussex Weald, whose family had prospered from local iron and Jamaican sugar.

> We afterwards went on the parade, where the soldiers were mustering, and found Captain Fuller's men all half intoxicated, and laughing so violently as we passed by them, that they could hardly stand upright ... The wind being extremely high, our caps and gowns were blown about most abominably; and this increased the risibility of the merry light infantry.[1]

It was a place where an eligible young woman might find a suitable match. Burney describes the antics of Peggy Pitches, whose father was a very rich brandy merchant:

> Peggy Pitches, who is the greatest little Coquet in Sussex, fixed her Eyes, and aimed her dart, at Captain Fuller – she smiled, tittered, lisped, languished, and played pretty all the Evening, – but the Captain was totally insensible.[2]

This is the same Brighton that so enthralled the young Lydia in *Pride and Prejudice*: 'In Lydia's imagination, a visit to Brighton comprised every possibility of earthly happiness ... she saw herself seated beneath a tent, tenderly flirting with at least six officers at once.'[3]

Lydia, of course, finds that flirtation can quickly lead to ruin – especially in Brighton, where the moral tone was set by the Prince of Wales and his raffish friends.

Regency Brighton – the green rectangle of the Steine, the Royal Pavilion and the Georgian terraces – continued to draw the wealthy down from London well into the nineteenth century. Queen Victoria did not approve, and soon abandoned the Royal Pavilion for the Isle of Wight, but others still came. Along the seafront, to Hove in the west and Kemptown in the east, developers threw up grand squares of imposing white houses.

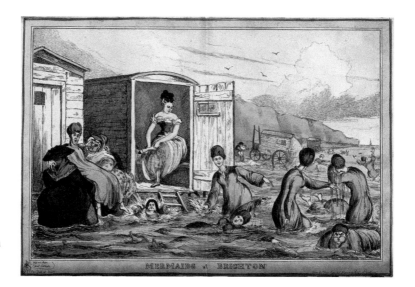

Right: Women
swimming in the
sea at Brighton,
W. Heath.
(Wellcome
Collection)

Below: Brighton
in the 1930s (with
Brighton Rock
kiosk).

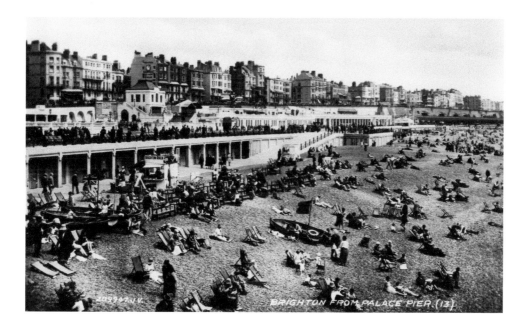

Hotels were built by the sea. There is the Grand Hotel, where Lord Alfred Douglas
famously stayed and sent the bill to Oscar Wilde. Thackeray wrote the early episodes of
Vanity Fair at the Old Ship. Much of Arnold Bennett's *Clayhanger* was written at the Royal
Albion in 1910. These seaside hotels have a long association with down-from-London
misconduct. The 1913 music hall audiences knew all about the town: 'It isn't the girl I saw
you with at Brighton/Who? Who? Who's your lady friend?' It was not just in the hotels:
in 1850 the town, with a population of 75,000, was said to have 400 brothels, presumably
small enterprises. There was even scandalous activity on the beach: the events that took

place there at night would 'beggar all description'.[4] 'Of course, Brighton wrote the book on sex' said Julie Burchill, 'and the rude bits were on every page'.[5]

In Fay Weldon's *Praxis* (1978) the heroine has happy childhood memories of Brighton beach, but finds herself working as an escort in a seafront club. *Praxis* is an odd name for a girl ('culmination, turning point, action; orgasm') and she has an extremely eventful life. One of her clients explains that the precarious nature of Brighton drives him to adultery. If nothing else, the sea air freshens the search for excuses.

Helen Zahavi's 1991 book *Dirty Weekend* brings sex and violence together in a new – or possibly a very old – combination. It was made into a dire film in 1993. The heroine, Bella, is tormented by a sadistic neighbour who threatens her on a park bench in Brunswick Square. After a visit to a clairvoyant – of which there are many in Brighton – she has an enlightenment. She steals into the neighbour's home and smashes his skull with a hammer. Several other sexual predators receive their just desserts, and after her dirty and vengeful weekend, Bella returns to London.

The working class joined in the fun quite early on. In 1844, the railway company sold its first excursion tickets from London, bringing a new class to rival the traditional visitors. For a long time, there was a stand-off: the masses came in summer and the elite visited the town for winter sun. In the early years of the twentieth century the masses took over the town and the piers; the modernist Saltdean Lido was built for them.

In 1938, according to Graham Greene (1904–91), there were 50,000 people a day arriving from London. The opening page of *Brighton Rock* describes the scene where the crowd poured into the town and 'stepped off in bewildered multitudes into fresh and glittering air'.[6]

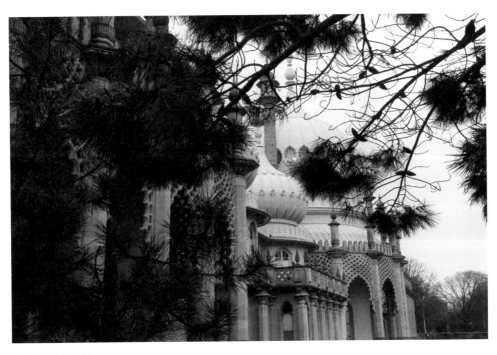

The Royal Pavilion.

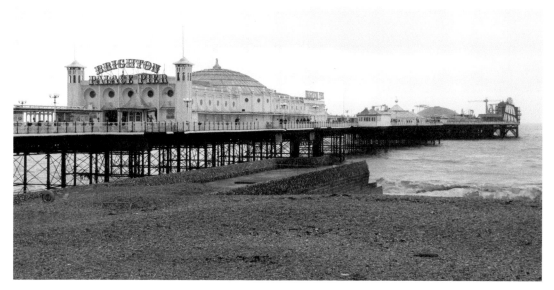

The Palace Pier.

Racecourse Hill.

The seafront came alive for a few gaudy months each summer, as the trippers poured in, but most of Brighton was not a holiday resort. The town began building railway locomotives in 1852, on a site that grew to 9 acres. The streets of workers' houses can still be seen under the great Victorian viaduct, which curves round to the London Road station. During the General Strike of 1926 there was serious disorder at the Battle of the Lewes Road, where striking transport workers attempted to keep the trams off the streets.

Graham Greene's Brighton was a place with appalling slums. The focus is on Nelson Place, a real slum in the town, waiting to be replaced by 'model flats'. Above all it is a place of villainy.

Real -life Brighton was home to racetrack protection rackets and knife crime. Greene insisted that he liked Brighton, and that novel created an imaginary underworld, a step away from the real town. Greene created a world where original sin rules. 'I've never changed. It's like those sticks of rock: bite it all the way down, you'll still read Brighton. That's human nature.'[7]

The town's authorities were horrified at the success of Greene's novel, and the 1948 *film noir* – with Richard Attenborough's vivid performance as a teenage psychopath – made matters even worse. This was followed by Patrick Hamilton's 1951 novel *The West Pier*, a remarkably creepy piece of work.

Keith Waterhouse (1929–2009) was the author of *Billy Liar* and a thousand newspaper columns. In the 1980s he had an apartment in Embassy Court, a marine-style modernist block on the seafront, just on the boundary of Brighton and Hove. It was built in 1935 and by the 1980s it was showing the signs of age; it was flaking away and had been threatened with demolition. For Waterhouse, decay was all part of Brighton's dissolute charm. The peeling stucco walls and the moral laxity were part of the attraction. In Brighton – with its multitude of pubs, all very small and very local – Waterhouse detected a certain disregard for the law.

> I would not wish to suggest that here is a town which could assist the police in their inquiries, but there is certainly a whole lot of wheeler-dealing going on.[8]

In his 2003 novel *Palace Pier* he returned to the idea, possibly because he had often been misquoted: 'Brighton had an air about it, and it wasn't just the sea air. It was a vague feeling of criminality ... As someone had written, Brighton had the air of having been invited to help the police with their enquiries'.[9]

Nowadays Waterhouse's Embassy Court – restored by Terence Conran – is as shiny as it first was back in 1935. The once dishevelled town of Brighton has become the bright

The site of
Nelson Place.

city of Brighton and Hove. It is one of the few south coast resorts to have a youthful and booming economy. Those who know and love the town are quite sure that, although the façades have been professionally repainted, the town's moral life is still as it always was.

For two decades now, Brighton's crimes have been perfect for Peter James. There is a very traditional core to his police thrillers. The main investigator, Roy Grace, is a reassuring figure, the middle-aged crusty cop with a troubled personal life, prone to hurling himself heroically into danger. There are, inevitably, conflicts with his fellow officers and superiors. Beyond these rivalries is the world of crime, including some horrible torments and murders. There is even a villain who has, in the basement of his luxurious Hove house, a torture chamber complete with a crocodile. The crocodile, incidentally, is called 'Thatcher' – not a popular historic figure in Brighton, which, with its gay-green-liberal culture, is sometimes known as 'Guardian City'.

James's books are realistic, though. He has close links with the local police and understands modern policing. His books can include glossaries of acronyms. He also knows Brighton. His Brighton is like Balzac's Paris, 'that eternal monstrous marvel ... city of a hundred thousand novels'. Brighton is formed from dozens of settlements, each with its distinct characteristics. The names are redolent of old London parishes: Elm Grove, Seven Dials, Roundhill, Fiveways. There are some houses where, as James's police put it, you need to wipe your feet when you leave. There are streets of bedsits and avenues of executive mansions. The Queen's Park area had a population straight out of the Guardian's Posy Simmons cartoons. Just a mile away is the well-manicured and leafy garden suburb of Preston Park.

Brighton may be portrayed realistically, but cannot be dismal for long. Julie Burchill's *Sugar Rush* (2003) finds its title in the sweet shop, just like Greene's *Brighton Rock* (1938) and Ian McEwan's *Sweet Tooth* (2012). Brighton is always the place where innocent pleasures go bad; or perhaps the place where evil things have a raffish charm.

> The sheer breezy romance of the place: chips and vinegar wrapped in newspaper, larger-than-life Knickerbocker Glories, bloody corpses left in suitcases at the station.[10]

Peter James.

This is from the Lynne Truss's 2018 comic novel *A Shot in the Dark*. It is a police detective story of a very traditional English kind, a homage to the trite Light Programme dramas of the 1950s, where a variety of middle-class stereotypes hilariously stumble across one another. The policemen take their names from the town's places: Constable Twitten, Sergeant Brunswick, Inspector Steine. There is something unserious about the city. Even the arrival of a new University in 1964, with buildings by Basil Spence, was tinged with frivolity. *The Listener* magazine called it 'The "With-It" University'. When a politician's twin daughters enrolled there, they featured, looking very Swinging London, on the front cover of *The Tatler*.

In the year that the University of Sussex opened, Susan Sontag published her famous essay 'Notes on Camp'. 'Camp' is the sensibility that 'converts the serious into the frivolous'. By any definition, the Royal Pavilion would certainly qualify as a 'camp' edifice and Brighton seems at times to be made for the word. Sontag gives examples of camp: *Swan Lake*, Tiffany lamps, old Flash Gordon comics, *King Kong* and the novels of Ivy Compton-Burnett. There is nothing here from Brighton, but that last item – the fiction of Ivy Compton-Burnett – is pure Hove.

Hove is the sedate western side of the city, where solid Victorian avenues descend towards spacious cream-painted Regency squares. Compton-Burnett (1884–1969) lived here for many years. Her father was a successful Harley Street homeopathist with a strong belief in sea air. The family came down from London to live at No. 30 First Avenue, and later moved to No. 20 The Drive. After her father's death in 1902 Ivy studied at Royal Holloway College. She returned in 1906 to educate her sisters, in a household dominated by the reclusive mother, Katharine. When the mother died, the role of domestic tyrant became vacant and Ivy stepped into it. Her siblings did not have happy lives: two of the sisters died in a joint suicide pact.

She produced nineteen novels under the name of I. Compton-Burnett and was well regarded as a modern and even modernist writer. The French critic and author Natalie Sarraute thought she was one of the greatest English novelists. The recurring themes – domestic rivalry and

Brunswick Square.

Above: The Drive, Hove, home of Ivy
Compton-Burnett.

Right: First Avenue, Hove, home of Ivy
Compton-Burnett.

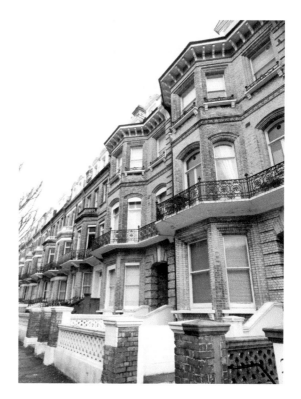

Rottingdean home of Rudyard Kipling and Enid Bagnold.

family feuds– derive from her years in The Drive. The titles are revealing: *Daughters and Sons, Brothers and Sisters, Parents and Children, Mother and Son.* The stories are conveyed in conversations between old-fashioned people with time on their hands.

> 'I wonder if there is anyone in the world who cares for me,' said Miles, leaning back in his chair. 'I often ask myself that question.' 'Then you should answer it,' said Ursula. 'It is less safe to put it to other people.'[11]

There are occasional fleeting allusions to an outside world. The alert reader can piece together tales of domination, incest and illegitimacy. Through all this, decorum is maintained – in appearances at least, Hove has always been a cut above Brighton.

To the east of Brighton is Rottingdean, looking rather satisfied with its old houses, its village green and village pond. Edward Burne-Jones lived here, as did his in-law Rudyard Kipling. When Kipling moved on to the Weald, North End House was taken over by Enid Bagnold (1889–1981). Before the First World War, Bagnold went to art school in London and lived a scandalously bohemian life. At one point she modelled for the sculptor Gaudier-Brzeska. She was a nurse in the First World War but was sacked for being too critical; she wrote a controversial and successful book about her experiences. In 1920 she married Sir Roderick Jones, head of Reuters, which meant that she was now Lady Jones and moved in the highest social circles. Bagnold is best known for her novel *National Velvet* (1935), the story of a girl who pretends to be a boy and wins the Grand National. The film turned Elizabeth Taylor into a teenage movie star. There was also a play, *The Chalk Garden*, set in Bagnold's own garden in Rottingdean. Again, there was a film, this time starring Katherine Hepburn. Her most notable novel is *The Squire*, which describes the few days before, during and after the birth of a child.

She knew Virginia Woolf, and sometimes encountered her in the Sussex countryside. When Bagnold was out on her horse, she would often see Virginia striding along and

wave down at her. One morning, while Bagnold was writing *National Velvet*, she invited herself over to the Woolfs' house in Rodmell. She had been socially embarrassed the day before and needed to talk about it. In Bagnold's version, the Woolfs were enchanted by her visit. Virginia saw it differently. She thought Bagnold wanted to show off her social connections, her fashionable living and her children. Deep down, thought Woolf, Bagnold was a conflicted woman because 'being a scallywag she married a very rich man'.[12] Enid was very rich and showy, with high social status, a keen interest in horses – and also a scallywag. Brighton has known a few people like that.

Right: Enid Bagnold by Maurice Asselin.

Below: The home of Burne-Jones in Rottingdean.

4. Men of Property

Chanctonbury Ring is an Iron Age hill fort that was planted in the eighteenth century with a ring of beech trees. Hilaire Belloc detected the demise of his beloved Sussex when, in 1936, he stood on the ring and could hear the sound of motor cars below.

It is a beautiful and dramatic spot. John Galsworthy (1867–1933) chose it as a perfect place for Jon and Fleur Forsyte to begin the reconciliation which concludes *The Forsyte Saga*. 'The Down dipped and rose again towards Chanctonbury Ring: a sparkle of the far sea came into view, a sparrow-hawk hovered in the sun's eye.'[1] The novels in the saga show the dangers of property disputes, starting with the appalling marriage of Soames and Irene in *The Man of Property* in 1906; even the outbreak of the First World War was, according to Jon, an argument over property.

Galsworthy disliked rapacious men of property, but was not averse to owning a fine building. In 1926 he was without a country place and set aside £3,000 to buy one. He looked at Bury House from the outside and decided there and then that he would have it.

Chanctonbury Ring.

Bury House.

It occupied a sheltered but shady position in the village of Bury, a few miles south-west of Pulborough. It was built in the Tudor style (albeit dating only from 1910) and had fifteen bedrooms. He agreed to the asking price of £9,000 and moved in on 16 September 1926. Inside, it was decorated with fastidious and expensive good taste.

The area was one he loved, and the novelist was moved to describe it in poetry. The construction of the house in 1910 had employed many villagers, but by 1926 the local economy was depressed. Galsworthy had the splendid opportunity to be a benevolent squire. He built houses for the villagers to live in and, to their surprise, gave them the

John Galsworthy. (Library of Congress, George Grantham Bain Collection)

houses in his will. His wife was not so pleased with his endless generosity, nor with Galsworthy's desire to talk endlessly about blacksmiths and wheelwrights.

In November 1932 he was playing croquet on the lawn when a telephone message came to say that he had won the Nobel Prize for literature. Otherwise these were not happy times for Galsworthy. His sales were falling and he was depressed at the turn that the world had taken. He continued writing while at Bury, but was suffering from an undiagnosed brain tumour, which was deeply debilitating. He was not, for example, able to deliver an acceptance speech for his Nobel Prize.

On 28 March 1933 his ashes were scattered over the South Downs from an aeroplane. His wife Ada had her ashes scattered there (in a more traditional way) in 1956.

Some writers were born in fine Sussex houses and moved on: Shelley at Field Place, for example, and Wilfred Scawen Blunt at Petworth House. Other writers became rich and famous, then moved to Sussex. Lord Tennyson had a vast house called Aldworth in Surrey, overlooking the Sussex landscape:

> You came, and looked and loved the view
> Long-known and loved by me,
> Green Sussex fading into blue
> With one gray glimpse of sea
>
> 'Green Sussex', Alfred Tennyson

His move was in some ways essential – guidebooks to the Isle of Wight were featuring his private walks and he was tormented by trippers. A similar motive helped Kipling move away from Rottingdean, where he lived from 1897 to 1902, to a grand house in the Weald. In any case, a successful writer would, like a successful banker, require a place in the country. In 1907 Conan Doyle bought a house called Little Windlesham in Crowborough.

Field Place, Horsham.
(British Library)

View of Blackdown.

He immediately dropped the 'Little' from the name and set about extending the property. From 1918 onwards, Rider Haggard occupied the extraordinary North Lodge in St Leonards on Sea.

In the west of the county, near Petersfield, is the grand mansion of Uppark, the creation of Sir Matthew Featherstonehaugh. There has been a great deal of restoration work, following a fire in 1989, but the effect of the house and the gardens – helped by Humphry Repton – is impressive. In the late eighteenth century, the house was owned by Henry Featherstonehaugh, a renegade and free-thinker, who briefly had the fifteen-year-old Emma Hamilton as a mistress. Later in life – much later, at the age of seventy-one – he married a milkmaid fifty years his junior. She inherited the estate. This did not alter the hierarchical nature of the establishment, a fact that would not have surprised H. G.Wells (1866–1946). In his novel *Tono-Bungay* (1909), the hierarchy of old country house is 'the clue to all England'. 'The fine gentry may have gone; they have indeed largely gone, I think; rich merchants may have replaced them, financial adventurers or what not. That does not matter; the shape is still Bladesover.'[2]

In *Tono-Bungay* the house is called Bladesover House and is supposedly in Kent, but it is really Uppark with 'its airy spaciousness, its wide dignity'. Wells knew the place very well. His mother was a housemaid there and she married one of the gardeners, Joseph Wells, in 1853. Joseph tried his hand at shopkeeping and cricket, but their children needed to work. Their fourth son Herbert George was initially a disappointment, unsuited to any obvious form of employment. At the age of fourteen, in a break between failed apprenticeships, Herbert spent some life-changing weeks at Uppark. He used the library, left by the free-thinking Sir Henry. There was also an old telescope, which he pieced together by

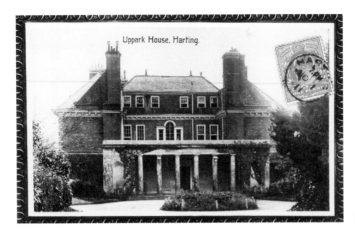

Uppark.

himself so that he could look at the planets. He spent many of his later holidays there. He learned to read and think, but also to observe the social hierarchy at work.

In Uppark, the hierarchy was given a strangely literal manifestation. There were a set of underground passages, ventilated by shafts, which allowed a little sunlight into the underworld. These were the passages that the underclass used to provide for the people upstairs or in the garden. This looks remarkably like the world of *The Time Machine* (1895). 'From every hill I climbed I saw the same abundance of splendid buildings, endlessly varied in material and style, the same clustering thickets of evergreens ... A peculiar feature, which presently attracted my attention, was the presence of certain circular wells, several, as it seemed to me, of a very great depth.'[3] These wells prompt the time traveller to think about underground ventilation. They are a link to the underworld where the brutal Morlocks, the descendants of the workers, are living. Above ground are the beautiful Eloi. The time traveller sees two distinct branches of humanity, the result of 'a real aristocracy, armed with a perfected science and working to a logical conclusion the industrial system of today'.[4]

H. G. Wells. (Library of Congress, George Grantham Bain Collection)

5. The People's Flag – Eastbourne, Bexhill and Hastings

In all previous civilizations, said the 'Communist Manifesto' of 1848, there were many different social classes. In the new world of capitalism, there would be only two classes. There were the owners and the workers, and an almighty reckoning was due. It would all be rather like H. G. Wells's story *The Time Machine*, but with a happy ending. The 'Communist Manifesto' was written by the impoverished Karl Marx and his rich friend Friedrich Engels. They both enjoyed trips to the south coast, and Engels became very fond of Eastbourne. It was, as it happened, a town that fitted nicely with their theory. The resort was divided sharply into rich and poor halves. Engels stayed in the rich half, obviously, usually at No. 4 Cavendish Place, close to the pier. A few hundred yards to the east – just past the Queen's Hotel – the land of the poor began. There was no seafront road linking these two halves of Eastbourne.

This arrangement was deliberate. Until the middle of the century, most of the shore had been owned by the Earl of Burlington and the Gilbert family. Once the railway arrived in 1849, these two landowners set about creating a new town, provisionally called 'Burlington'. Later this idea was dropped and the Earl of Burlington became, in any case, the Duke of Devonshire. They designed the 'Empress of Watering Places', attracting the

Eastbourne in the 1890s.

better class of summer visitors. It was a successful venture. In 1887, George Gissing describes a working-class London girl, arriving in Eastbourne by train: 'How astonishingly clean the streets were! What great green trees grew everywhere!'[1]

Some parts of the shoreline had been occupied by fishermen, who were ruthlessly moved out to allow a sea wall to be built. Obviously, the rich required servants and services, but otherwise the poor were discouraged in the western half of the town. In the

Above: Cavendish Place.

Left: T. H. Huxley's house.

Pevensey Road.

1880s and 1890s the town council was especially bothered by the Salvation Army, whose bands and public meetings were lowering the tone of the place. One distinguished inhabitant of the town was T. H. Huxley, who lived in Staveley Road and had a deep dislike of the 'despotic' William Booth and his Salvation Army. Huxley was not alone in his distaste. The town council repeatedly prosecuted the Salvationists when they met, but took little action when the Salvationists were attacked by local mobs. In 1892 Parliament had to intervene to allow public meetings.

Most of the writers who knew Eastbourne stayed at the rich end and many of them were summer visitors, like Lewis Carroll, who lodged in Lushington Road. T. S. Eliot came here for his honeymoon with Vivienne in June 1915, and it was a disaster. He spent at least one night sleeping in a deckchair under the pier. The poet Christina Rossetti spent summers in the town, but stayed in the unfashionable part, at No. 111 Pevensey Road. Even this may be too expensive: she writes in 1880 that she may have to move soon as the rents were so high. Her sister was in the All Saints convent hospital at Meads and Christina often stayed there, in a small room without wallpaper. On 26 June 1885 she wrote a prose piece about a 'self-haunted' spider on the wall here, a strange descriptive story that has kept some critics and analysts busy.

At No. 62 Pevensey Road there lived a baker called George Vine. He had a number of boys working for him. In 1880, while Christina lived at No. 111, the baker employed George Meek, a twelve year old who had a weak constitution and was blind in one eye. Meek had been born to a poor local family in East Street, by the Rose & Crown. His father was a skilled plasterer, but the building slump forced him to break stones for relief work. He went to America and was soon followed by Sarah, his wife. This left George to live at his grandparents' house, which he enjoyed greatly. His grandmother had odd jobs: Meek remembers wanting to turn the mangle at a laundry where she was working. The laundry was in Cavendish Place, so it is possible that she was washing Friedrich Engels' sheets.

Bath chair. (British Library)

George Meek grew up just outside Eastbourne, in the village of Willingdon, and enjoyed his schooling there. Unfortunately, his mother returned to England. Her husband had died in a theatre fire in Brooklyn. She began to live with an unpleasant butcher-turned-cabby and George was obliged to join them. It was a harsh upbringing. When he was at the baker's, his mother took all of his wages; she occasionally allowed him a penny for himself on a Sunday. He soon left home and never really settled. Eventually he drifted into 'bath chair-work', where no qualifications were required.

A bath chair was a chair on wheels. It was named after the city and was not designed to take people to the bath. Eastbourne was a favoured resort for convalescents, many of whom would need to be pushed around in a bath chair. In the early 1900s, there were hundreds of bath chair men in the resort, most of them waiting by their machines in the hope of a fare. Meek described his life in an autobiography.

> I am writing this on the 19th of August 1908. During the month so far, I have earned only one casual shilling. I have a small contract job but I am free from twelve -o-clock every day. And the other men are standing around in glum hopelessness.[2]

The chair men must get up early to have a good place in the queue by the Grand Hotel. They rent their chairs from hard-nosed owners who are quick to sneak up and remove the handles if the rent is not paid promptly. The casual workers cannot even be relied upon to stick together. His comrades in the bath chair business were also his competitors. They would try to capture business by saying that George liked a drink or was a socialist (both true, as it happens).

The end result was a life of poverty and debt. Even with his wife working – she ironed clothes in a laundry, piece work – there was only money for a three-roomed flat with broken windows, howling neighbours and the sound of drunken brawls at night. Hanging over everything was debt and the possibility of being sent to gaol, a possibility that materialised in Meek's case. He drank too much and blamed the publicans in part for this. They insisted on selling tasty food like cheese, which made you want another drink. It is not only the bath chair men who suffered the curse of casual employment: the drivers of new-fangled taxis were just as badly treated.

Meek became a socialist. He set up a local bath chair man's union, and was an early member of the Social Democratic Federation. It was as a socialist that he contacted H. G. Wells, explaining that he wished to write a book on ethics. Wells persuaded him to describe the world that he knew and the result was a modest literary success: *George Meek, Bath Chair-Man; By Himself* (1910), with an introduction by H.G. Wells. It was well received, mainly for its cheerful honesty. It was one of many escape routes Meek had tried. He had previously proposed writing plays and had written poetry; he had worked backstage at the theatre. He had also invented an early form of talking picture, synchronising a film projector and a phonographic cylinder. Sadly, the Pathé Frères company was not interested. Meek was one of the aspiring poor – think of Jude the Obscure – and his education had been greatly helped by the socialist groups he belonged to.

George Gissing's *Thyrza* (1887) is partly set in Eastbourne. It deals directly with the question of educating men like Meek, and even more directly with educating women. Thyrza Trent, the heroine, is a young hat trimmer in Lambeth who agrees to marry an older man, Gilbert Grail. Grail works brutal hours in a soap-and-candle factory and then tries to improve himself in the evenings. Into this world comes an idealist called Egremont, who has men like Grail in his sights. Egremont is – like Engels – the son of a factory owner who has committed himself to improving human society.

> What I should like to attempt would be the spiritual education of the upper artisan and mechanic class. At present they are all but wholly in the hands of men who can do them nothing but harm—journalists, socialists, vulgar propagators of what is called freethought.[3]

This ambition leads him to run classes, offering sweetness and light to the ungrateful workers of Lambeth. The one worker who seems ready to respond is, unfortunately, engaged to Thyrza. Egremont and Thyrza fall in love – bad luck for Mr Grail – and she sets out to improve herself in Eastbourne. Eventually, as Engels might have predicted, class overcomes love, and there is no happy ending for anyone.

Eastbourne was famous for its schools. Rumer Godden, who was born in Eastbourne, lived for part of her childhood in India, but was sent back to attend school here, at Moira Hall. St Cyprian's, a preparatory school in Summerdown Road, produced a number of writers. These included Gavin Maxwell (*Ring of Bright Water*) and Alan Clark, the Conservative politician whose diaries became bestsellers. The class of 1916 was a remarkable one: Cyril Connolly won the English prize, Cecil Beaton won the drawing prize, while the Classics prize went to Eric Blair (1903–50), who later wrote under the name of George Orwell.

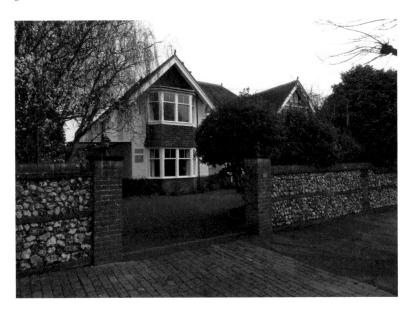

St Cyprian
House.

St Cyprian's was a boarding school whose pupils started at eight years old. The school was aimed at young boys who wished to go to the great public schools – especially Harrow and Eton. Some poor boys in the school were offered reduced fees. This, according to Orwell, was not done in a spirit of social justice. St Cyprian's selected bright poor children and crammed them into passing prestigious exams.

The school has disappeared now, though the headmaster's house remains. The main building burned down in May 1939 but all of the boys, including Alan Clark, were rescued. Around this time Orwell wrote an excoriating account of his time there. There are details of beatings and humiliations and of physical squalor. Above all, there is a deeply felt personal attack on Cecily Wilkes, who ran the establishment. The boys knew her as 'Flip' and many of them loved her ever after. She had a deep love of English language and literature, and the experts see traces of her ideas in the mature Orwell. Nonetheless, he hated her. In theory the school was meant to inculcate Christian values, he said, but in practice the one thing that mattered was money. Rich boys were treated better than poor boys.

Orwell's essay had the ironic title of 'Such, Such Were the Joys' and was published in the United States – with the school's name disguised – in 1952. It was not published in England until 1968, when Mrs Wilkes was safely dead and could not sue for libel. The school, according to Orwell, was not just cruel but totalitarian. From this dystopia there is no escape, even in one's own mind. The crushing humiliations perpetrated by Flip and her husband are such that the young Eric Blair believed that he deserved them. This is the world of *1984*.

Bexhill-on-Sea

A few miles to the east of Eastbourne, Bexhill was initially the creation of an aristocrat but its cultural life has an unexpectedly socialist tinge. The resort was created in the nineteenth century by the 7th Earl De La Warr. The 9th Earl, Herbrand, was responsible for the De La Warr Pavilion, a famous piece of modern architecture. Herbrand had been

David Hare's childhood home.

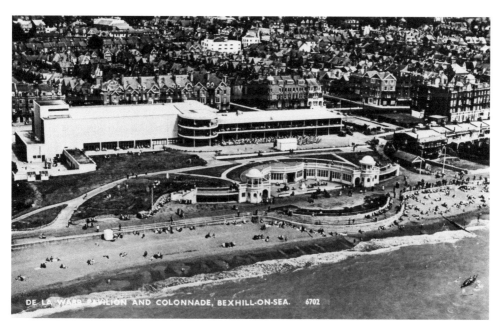

Bexhill Pavilion.

a pacifist in the First World War and had then become the first Labour member of the House of Lords. He was a minister in Ramsay MacDonald's government. The town was home to the socialist and pacifist Minnie Pallister, a well-known writer and broadcaster.

Spike Milligan, the comedian, was stationed there in the Second World War; the town features in his memoirs. From the leafy part of the town came Angus Wilson, who

lived at Dorset Road and Marina Court and was familiar with the problems of a family in financial decline, needing to move regularly. The resort was also, surprisingly, the birthplace of modern Thai literature. The young Arkartdamkeung Rapheephat (1905–32) came to stay in Bexhill and gave it a prominent part in his 1929 novel *The Circus of Life*. After the Second World War, the semi-detached houses of Bexhill gave rise to David Hare, the left-wing dramatist. Hare thought that Bexhill sharpened his appetite for life – after the insufferable tedium of Bexhill anywhere else looked interesting.

Hastings

Hastings has had a longer history than Eastbourne, but it too attempted to be a resort for the gentility. The modern history of the town was summarised by Sheila Kaye-Smith (1887–1956) in her novel *Tamarisk Town* (1919), named after the Tamarisk steps, the spot where she decided to write the novel. Kaye-Smith creates an imaginary character, Edward Moneypenny, who single-handedly builds the resort. Real events spanning many decades are woven into Edward's personal and romantic trajectory. At the beginning, the fictional town of Marlingate is a sleepy place with a covering of tamarisk trees, but that will change. Edward Moneypenny will develop another seaside town into (as always on the Sussex coast) a resort for the better class of visitor.

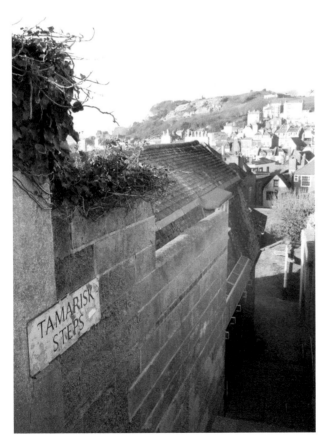

Tamarisk Steps.

Robert Tressell. (Steve Peak)

Hastings developed rapidly, to the annoyance of Thomas Carlyle, who went there for peace and quiet. 'Nothing but dust, noise, squalor, and the universal tearing and digging.'[4] Neither the fictional Moneypenny nor his real-life counterparts would be personally building anything, of course. They employed workmen to do that. In Hastings, remarkably, one of these workmen put pen to paper. He was Robert Noonan, whose novel *The Ragged Trousered Phlianthropists* was published under the name of Robert Tressell.

Robert Noonan (1870–1911) was an Irishman from a comfortable background who drifted into working as a painter and sign writer. The bourgeois homes of the seaside towns were built and decorated by an army of casual skilled and semi-skilled workers, constantly in fear for their livelihoods. In Noonan's case, his high skills as a sign writer kept him in work, but his ill-health meant that he was always fearful that his family would end up in the workhouse. Like other decorators he worked long days for little money. Somehow, he found time to take part in local socialist politics. We hear of him in the company of the Eastbourne bath chair man George Meek, and there is a photograph of him addressing a meeting in Wellington Square. The Social Democratic Federation also organised meetings on the beach. Somehow Noonan managed to produce a 1,600-page manuscript of a novel, which he called *The Ragged Trousered Philanthropists*. He did not find a publisher and tried to discard the manuscript, but his daughter Kathleen saved it. Noonan was a well-educated man who spoke several languages and had a large number of books. His sister was appalled by his wilful decision, as she saw it, to stay poor.

The title of *The Ragged Trousered Philanthropists* might suggest a feel-good story of working men supporting each other. This is not true. The title refers ironically to their stupidity: 'All through the summer the crowd of ragged-trousered philanthropists continued to toil and sweat at their noble and unselfish task of making money for Mr Rushton.'[5] The working class are philanthropists because they voluntarily hand the

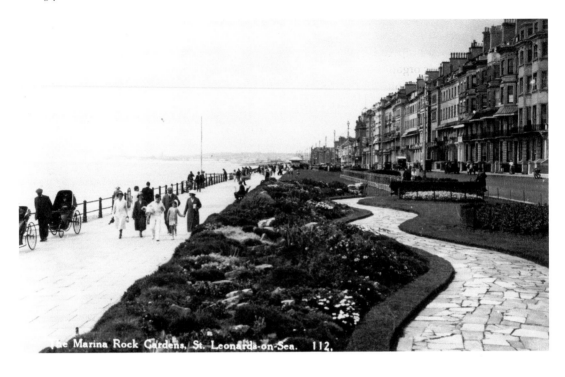

The Marina Rock Gardens, St. Leonards-on-Sea. 112.

Above: Saint Leonards (with bath chairs).

Left: Millward Road building where Tressell lived.

fruits of their labour over to the capitalists. In fact, Tressell despises all philanthropy. Municipal philanthropy allows the greengrocers on the council to offload their old stock. The philanthropic organisations have well-paid managers and most philanthropy allows the wives of brutal capitalists to show off their virtues. The local Bonfire groups enjoy themselves but collect for charity from the poor onlookers.

The novel describes Mugsborough as an inland town, rather than a seaside resort. Perhaps this was done to prevent any libel actions since the novel closely follows actual events in Hastings. The first edition had the subtitle 'Being the story of twelve months in Hell, told by one of the damned, and written down by Robert Tressell.' The painters and decorators have no secure contract. The owners want every minute of work that they can extract, and the supervisors are constantly tiptoeing around the site hoping to catch someone idling. There is no great pride in work, since the owner demands that they skimp as much as possible. At the end of the day there is only the grinding poverty of a rented room to look forward to, and endless round of debt and repayments. Malnutrition and ill-health are always present, and the descriptions of the poor are truly distressing.

There are large tracts of socialist polemic in the book, provided by the character of Frank Owen, a Tressell look-alike. For Owen, the truth of socialism is self-evident.

London Road where Tressell wrote *The Ragged Trousered Philanthropists*.

His fellow workers are prepared to listen to long lectures on the subject, but they do not understand or approve. The main house that they are decorating is called The Cave, which is Plato's Cave, where everybody mistakes shadows for realities, where the working classes accept the picture of the world painted by their superiors. This is why Hastings is called 'Mugsborough', the town where the mugs live. Oddly enough, there is no description of a trade union meeting, even though Owen is briefly described as a branch secretary.

The lives of the workers are described in close detail, but the middle classes are presented in a crude social satire. The Mugsborough Organized Benevolent Society, for example, had subscribers including Sir Graball D'Encloseland, Lady D'Encloseland, Lady Slumrent, Mrs Starvem, Mrs Slodging, Mrs Knobrane, and Mr Didlum...[6]

Tressell is repetitive, with heavy doses of sarcasm, and the book is shapeless (but not in a modernist way). There are attempts at form – the action takes place over about a year and ends in deaths. There is an attempt at a temporarily happy ending, when one workman proves to be a middle-class researcher in disguise and hands out lifesaving gifts at Christmas. This is a surprising end, given the author's hatred of philanthropy. For all

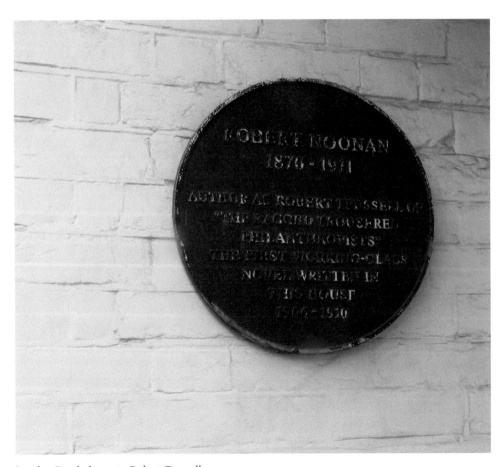

London Road plaque to Robert Tressell.

of its shortcomings, however, the novel helped to form the British Labour movement and was especially influential among working-class Labour MPs.

One of Noonan's fears was that his daughter Kathleen might end up in a workhouse. Hastings Workhouse was, paradoxically, the place of liberation for Catherine Ann McMullen. She was the illegitimate daughter of a young alcoholic mother and grew up in the slums of Tyneside. She started work as a laundress when she was thirteen years old, and she worked hard. She was determined to leave her appalling childhood behind, an ambition which earned her few friends in her home streets. She arrived in Hastings in 1930, managing the laundry at the workhouse. She loved Hastings because there was so little noise or poverty. She saved her money and bought a huge house, turning it into a residential business. Life still had some unpleasant surprises: her health meant that her pregnancies ended in miscarriage, and her mental health became fragile. She did, however, have a successful marriage. She married a young Oxford-educated teacher named Tom Cookson and began to write novels in the late 1940s. Her subject matter was often the harsh world of her Tyneside childhood, beginning with *The Fifteen Streets* in 1952. Her autobiography *Our Kate* was published in 1969. For the next thirty years Catherine Cookson was one of the bestselling authors in the country and one of the most prolific, with over 100 titles to her credit. Eventually she moved back to the north-east. She was bedridden for the last two years of her life, but kept writing until she died, aged ninety-one.

Noonan was forty when he died of tuberculosis in 1911, the same disease that killed George Orwell in 1950. In his later years, Orwell had achieved a remarkable success with

Rider Haggard's house in Saint Leonards.

Coventry Patmore's house.

his short allegory *Animal Farm* (1945). It describes what happens when the government takes over everything, and the pigs take over the government. The farm in question is close to a village called Willingdon, where the expropriated human Farmer Jones visits the Red Lion public house. Since a village of Willingdon lies just a little north of Orwell's school in Eastbourne – and since the village does indeed have a Red Lion pub – there has been a belief that *Animal Farm* is set in the Sussex Downs. The local newspaper questioned whether this could be true: the local publicans would not possibly allow a customer to become too drunk.[7]

George Meek died in 1921 with cancer of the tongue and 'general exhaustion'. His trade was also dying; by 1945 there was only one bath chair man remaining, a Mr Manser. The demand for bath chairs had dwindled, and in any case the Luftwaffe had destroyed seven of the remaining machines.

Friedrich Engels spent most of his last months in Eastbourne, suffering from throat cancer. He died in London and was cremated in Woking, but his ashes were taken down to Eastbourne on 26 August 1895. Eleanor Marx, with a couple of comrades, hired a boat and a pilot in Eastbourne, and they rowed out to the sea, 6 miles off Beachy Head, where – as requested by the deceased – the ashes were scattered.

6. A Cottage of One's Own – from Lewes to Beachy Head

At Firle you can visit the Ram Inn where, on 22 August 1917, Katherine Mansfield waited for the 'fly' to take her back to London, after visiting Virginia Woolf. Nearby, Charleston farmhouse is saturated by Bloomsbury: this is where John Maynard Keynes wrote *The Economic Consequences of the Peace.* Just a few miles north, at Ripe, is the cottage where Malcolm Lowry spent his last days – by the time he arrived in Sussex, the author of *Under the Volcano* was ruined by alcohol. He died through 'misadventure' in June 1957 and is buried in the Ripe churchyard. In the middle years of the last century, the pastoral landscape of the downland seemed to have more writers than sheep.

The South Downs are the hills that run parallel to the coast and finally fall into the sea at Beachy Head. The coast has a series of spectacular white cliffs known as the Seven Sisters (though, as with the rainbow, it takes some imagination to distinguish the seven). Just inland is a stretch of close-cropped downland and small settlements in the undulating

The South Downs.

Malcolm Lowry's house in Ripe.

landscape. It has been challenging writers for over 200 years. Charlotte Smith made one of the first known attempts.

> I breathe your pure keen air, and still behold
> Those widely spreading views, mocking alike
> The Poet and the Painter's utmost art.
>
> 'Beachy Head', Charlotte Smith

A hundred years later, Richard Jefferies was working towards a description: 'The sun searches out every crevice amongst the grass, nor is there the smallest fragment of surface which is not sweetened by air and light. Underneath, the chalk itself is pure, and the turf thus washed by wind and rain, sun-dried and dew-scented, is a couch prepared with thyme to rest on.'[1] In the 1920s, E. V. Lucas said the Ouse Valley had very clear air 'producing on fine days a blue effect that is, I believe, peculiar to the district'.[2] We could furnish a decent-sized library with attempts to describe the effects of light on this landscape. It is still going on in the twenty-first century:

> At Alciston white light comes shafting through the plain church windows as if the pale sun itself had turned protestant; at Alfriston in the afternoon the reed beds turn a tawny orange-grey, gently luminous beyond hedges of dark ilex and yew.[3]

Eleanor Farjeon (1881–1965) wrote children's fairy stories set in and around Alfriston, and the Martin Pippin books have very detailed descriptions of Sussex. It is believed locally that her best-known hymn– 'Morning Has Broken' – began in the village. However, Farjeon did not live permanently here – she lived in Hampstead. Her lover Edward Thomas could see the whole expanse of the Downs from his study near Petersfield, and wrote extensively about Sussex, but his permanent home was not here. In the late

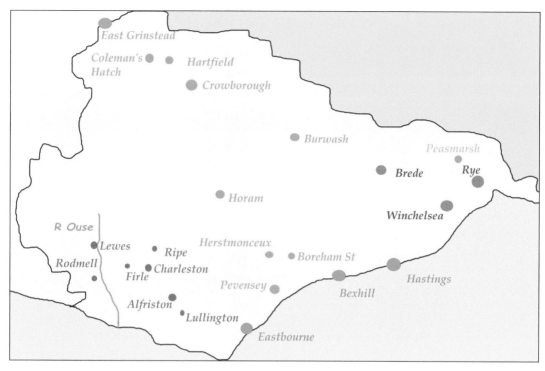

Map of East Sussex.

Alfriston Church.

nineteenth and twentieth centuries, the downland was lovingly described by an unending stream of visitors from London. The beautiful landscape was just a couple of hours away by train. In the interwar years, the 'green electrics' left London Victoria station every hour, and could drop the weekender into the silent countryside.

Lullington

In the 1930s Ulric Van Den Bogaerde was the art editor of *The Times*, responsible for photographs and illustrations accompanying the news stories. He rented a cottage in Lullington, for him the most beautiful part of England. Sometimes his two children moved down to the cottage for their holidays. Usually the children – Derek and Elizabeth – lived with a family servant called Lally, but sometimes they had their parents as well. Ulric would have to ring the newspaper each day, even Christmas, to see if there was an important story to attend to. This was a typical use of an old Sussex flint-and-brick cottage, a weekend home for middle-class Londoners. We know about it because one of the children – using his stage name of Dirk Bogarde – wrote his autobiography. *A Postillion Struck by Lightning* appeared in 1977and was an instant bestseller. Lullington was pictured on the cover, along with a photo of the two children, taken in 1927.

In 1977 Dirk Bogarde (1921–99) was a successful actor, and the later part of *Postillion* is a conventional account of a showbiz career. It was the earlier pages that earned the praise of the reviewers, evoking the lost world of the countryside before gentrification. There are beautiful fields and ash trees, but also old bedsteads and tin cans left to rot, as well as moments of childhood reverie.

The book's locations are still recognisable: Red Barn Hill, Lullington Church and The Long Man of Wilmington are all much as Bogarde describes them. The people are

Postcard of 'High and Over' hill.

Alfriston from Lullington.

different now. According to Bogarde's story, the locals included Nellie, who lived with her cats in a battered old caravan. She had the power to cure toothache, nettle rash and unwanted pregnancies.

In 1992 Bogarde published *Great Meadow*, a book devoted to his childhood months in Sussex. This time he tries to enter deeper into the world of childhood, using a language closer to the language of a child. Bogarde recalled a time in the 1930s when he with his friends Reg and Perce were fishing for pike in a deep pond beside the Ouse. Keeping still and silent, waiting for pike to show, the boys see a tall, thin woman with wispy hair carrying a posy of flowers. This old woman is forever interrupting his fishing, says Perce, a regular nuisance, moving around like a witch, wagging her stick. 'Londoner. From over there at Rodmell ... a bit do-lally-tap ... she writes books.'[4]

If this is a true account – and there have been questions about Bogarde's reliability – we have a rare glimpse of how the Sussex villagers viewed their neighbour, Virginia Woolf.

Rodmell

'Evening is kind to Sussex, for Sussex is no longer young'[5] wrote Virginia Woolf in her essay 'Evening Over Sussex: Reflection in a Motor Car'. It was probably written in 1927, at a time when Woolf's writings gave her enough money to have a car of her own.

Virginia Stephen, as she then was, rented a house in Firle in 1911. She called it Little Talland House, a reference to the idyllic Talland House, the holiday home in St Ives in

Cornwall that featured in *To The Lighthouse*. Little Talland House, with its mock-gabling, was not beautiful but it was convenient. Later Virginia and her sister Vanessa moved to Asheham, overlooking the River Ouse. Leonard Woolf was with Virginia when she discovered Asheham, and the two were married soon after in 1912. Virginia managed to write there, working on *The Voyage Out* (1915), and the house was well situated for walking on the Downs.

Unfortunately, Virginia's mental health was deteriorating. Asheham was in a pleasant spot, close to the sea and offering splendid views over the South Downs and the Ouse valley. Leonard's literary career was beginning well. Although he was busy with his political activities, he had published *The Village on the Jungle* – set in Ceylon – in March 1913. Virginia's *The Voyage Out* had been accepted by a publisher in April, but her world had closed in since getting married a few years earlier, and she needed constant supervision. All through the summer of 1913 she experienced anxiety and threatened to stop eating. She was prescribed veronal to combat insomnia, but had overdosed on it. Asheham was a place she could convalesce. That Christmas she had the usual set of servants but also two mental nurses. Her therapy for the Christmas season included cleaning the drawing room. In 1919, Asheham had to be vacated, because the owner needed it for his farm staff, and Virginia wrote her short story 'The Haunted House' about it.

She then bought a house in Lewes, but did not like it; she soon sold the Lewes house and bought Monk's House in Rodmell. It was a primitive place, and the village had no electricity or running water. It did, however, have a bustling life from which the Woolfs inevitably felt detached. In Rodmell, they were in the deep world of England but Virginia and Leonard could only watch on from the outside. Then there is the usual refrain that all of this is dying. They had bought Monk's House for £700 but just six years later it was valued at £2,000, and the real locals were giving way to newcomers. Next door to Woolfs,

Little Talland
House.

Monk's House.

for example, was Mrs Shanks, who pierced the rural air asking Mr Shanks how he would like his cocktail.

Edward Shanks, incidentally, was a First World War poet, a novelist and a critic. He wrote a science fiction story, *The People of the Ruins*, whose hero is thrown into suspended animation and wakes up 150 years into the future. As he makes his way from a ruined London through Sussex, he encounters some Sussex people at their pub: 'Inside, the worthies of the village were rejoicing after the day's work. Jeremy could hear the slow, long drawn-out sound of Sussex talk, not changed by a couple of centuries (or rather thrown back by that interval into the peculiarity it had at one time seemed likely to lose) and the noise of liquor being poured and of pots being scraped on a table. Then a voice was raised in song.'[6] They are singing a traditional and not fully comprehensible old song, 'Pack up my troubles in some owekyebow, And smile, smile, smile'. Mr Shanks was the first winner of the Hawthornden Prize, and is now remembered, if at all, as Mrs Woolf's vulgar neighbour.

The Woolfs kept Monk's House for the rest of their lives. They were known locally as good employers, paying over the going rate for their servants, but there was still a distance. Leonard worked and argued for decades alongside Percy Bartholomew, the gardener. When Leonard came to publish his bestselling autobiographies, Percy was referred to briefly and anonymously as 'my gardener'.In Rodmell, their social life was provided mainly by visitors from London. Maynard Keynes had Tilton House near Charleston, and in 1938 he invited a group of friends there to listen to him read from his autobiography. It was a chapter called 'My Early Beliefs', and the audience included many of his Sussex neighbours: Virginia and Leonard Woolf, Vanessa Bell and Duncan Grant from Charleston, and Quentin and Angelica Bell (children of Vanessa). There was also E. M. Forster and David Garnett. This was deepest Bloomsbury. It is what the Rottingdean author Enid Bagnold called 'a kind of glittering village with no doors'.[7] Angelica Bell was

described as the daughter of Clive Bell. In fact, she was the daughter of Duncan Grant, who was the lover of Garnett (who later married Angelica).

Woolf spent a lot of time at Monk's House in her final years, especially when war began. Buildings in Bloomsbury were being bombed, and even in Rodmell she could hear and see the bombers making their way to London. Her last novel, *Between the Acts*, is set in some unspecified part of England, but it has Sussex written over it. A pageant is being organised. It is comic, but there is a brooding historical perspective, revealing a deepest England. The local villages and the local people have names that were in the Domesday Book, but now the chatter is about Jews and refugees; overhead a formation of twelve planes interrupts the proceedings. After the pageant, Lucy reads from a H. G. Wells-style history of humanity, and the house is lost in darkness: 'It was the night that dwellers in caves had watched from some high place among rocks.'[8]

Left: Bloomsbury family values: Firle churchyard.

Below: The path from Monk's House to the Ouse.

At the end of March 1941 Virginia Woolf wrote a note for Leonard, put on her fur coat and wellington boots, walked down to the Ouse and drowned herself. She had put stones in her pockets. The river is tidal here, and the body might well have floated out to sea. In fact, it was discovered by some young people on 18 April. Leonard lived at Rodmell for the rest of his life. Virginia's ashes are in the garden at Monk's House. Her sister Vanessa is buried in Firle churchyard.

Right: Sussex by car in the 1920s.

Below: Farmland near Rodmell.

The Downs near Lewes

Lewes

If you follow the Ouse a few miles north of Rodmell, you will come to Lewes, the county town of East Sussex. It has a long Protestant tradition, still evident in its annual celebration of Guy Fawkes Night. Back in 1577, the town was treated to the largest mass burning in English history, when ten Protestants were incinerated at one time. The memory of this was revived by Sussex historian M. A. Lower when he published *The Sussex Martyrs* in 1851. Lower himself was not happy with the bonfires, which existed before he published his book, but it had an effect. In a spectacular Guy Fawkes Night in 1868, the effigy of the pope was not simply burned but was blown up with gunpowder.

Nowadays the town population is closely linked to the University of Sussex and the high street has the very modern look of a well-preserved old market town with expensive boutiques. Lewes still has its own brewery (Harvey's, established in 1820), and there is plenty of organic wholefood to be eaten. Virginia and Leonard Woolf lived here for a time, but its best-known writers did not write here. Foremost of these is Thomas Paine (1737–1809), who has a statue in the town. He lived in Lewes for six years, working as an excise officer (he was sacked) and running a tobacco shop (which went into liquidation). His writing career lay in future, after he had gone to America. John Evelyn (1620–1706),

Thomas Paine's house in Lewes.

the diarist and botanist, spent his childhood in Lewes. His parents sent him from London to Lewes to avoid an outbreak of plague and he lived with his grandparents at Southover Grange. At the age of seven, Evelyn laid the foundation stones of St Michael's Church by the Ouse. His grandfather built a new church because the existing church in Lewes was too ritualistic and dangerously close to popery. Evelyn, like Paine, wrote little in Lewes, although at the age of ten he began to write a diary of sorts. Paine's tobacco shop would not fit into modern Lewes, but Evelyn might be at home.

> Whole nations – flesh devourers, such as the farthest northern – become heavy, dull, inactive, and much more stupid than the southern; and such as feed more on plants, are more acute, subtle, and of deeper penetration.[9]

in the hunting and shooting and highly carnivorous court of Charles II, John Evelyn was a vegetarian.

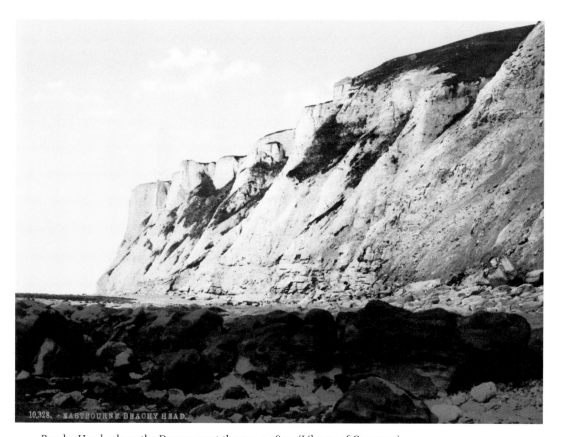

Beachy Head, where the Downs meet the sea, *c.* 1890. (Library of Congress)

7. Rye Society

In 1898 Stephen Crane, the young American author of *The Red Badge of Courage*, was lent a house in Brede, close to Rye. From Rye the novelist Henry James used to cycle up to visit him. Crane was ill, frail and nearly bankrupt, but presented a play at Brede School House on 28 December 1899. It was called *The Ghost* and written, mainly, by Crane, but he was helped by an impressive set of co-authors: Henry James, George Gissing, Rider Haggard, Joseph Conrad and H. G. Wells, among others. The characters included Dr Moreau (courtesy of H. G. Wells) and his fictional son Peter Quint Prodmore Moreau, borrowed in part from James's *The Turn of the Screw*. Mrs Wells played the piano. The play – perhaps more of a pantomime – had this single performance and did not move on to the London stage. Crane had a pulmonary haemorrhage the day after, and H. G. Wells had to cycle off to find a doctor.

Rye.

Rye was that kind of town then. Henry James (1843–1916) produced some of his greatest works in Rye: *Golden Bowl, The Ambassadors* and *The Wings of the Dove*. He worked at his home, Lamb House, and more especially in its summerhouse or 'Garden Room', sadly destroyed by a bomb in 1940.

Above: Brede Place.

Right: Henry James. (Library of Congress, George Grantham Bain Collection)

Lamb House was built in 1722 and had housed by some of the town's most prominent citizens. Henry James set eyes on it in 1896 and wanted it; when it became available (almost immediately), he speculated that he might have developed psychic powers. He stayed in London for a few months in 1897 while the house was decorated to his standards, but was obsessed by his new home. It was his first house, and it had 200 years of history attached to it. He also had a sense that, with the advancing years, it would be his last house. He was so enthralled that he began to write a story about it while waiting to move in. It was not a happy story. *The Turn of the Screw* began life when James heard a disturbing tale from the Archbishop of Canterbury. It was all about servants in an old country house who had corrupted children and returned to haunt them. The novella produced extreme reactions, even in the author himself, who found the finished proofs frightening.

> The story had held us, round the fire, sufficiently breathless, but except the obvious remark that it was gruesome, as, on Christmas Eve in an old house, a strange tale should essentially be.[1]

As the story progresses, there is something 'undefineably astir in the house'.

In later years his secretary – amanuensis rather – at Lamb House was Theodora Bonsanquet, who was deeply interested in his novels and could produce a fine parody of his style. Theodora was also fascinated by Ouija boards and seances. She was able to discuss spiritualist matters with Henry's brother, the psychologist William James. In her later years, she took up automatic writing and found herself in the 1930s being dictated to by the long-dead novelist. Even if the house is not haunted in any psychic sense, there must be literary ghosts here. There has even been a fiction about it called *The Haunting of*

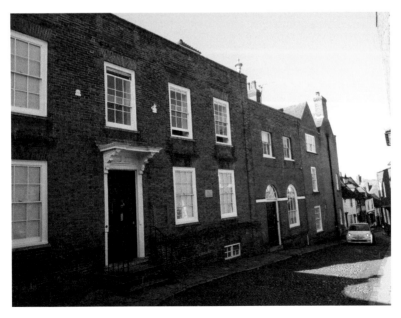

Lamb House.

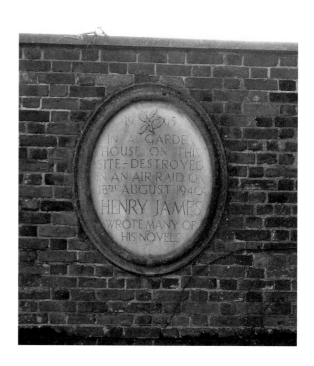

Right: Lamb House Garden Room.

Below: Conrad AIken's house, Rye.

Lamb House (1993) by Joan Aiken. She, incidentally, was born in Mermaid Street, Rye, the daughter of Conrad Aiken, the American poet.

After James died, the house was taken over by E. F. Benson (1867–1940). He was the son of the same Archbishop of Canterbury who had launched *The Turn of the Screw*. Benson was the mayor of Rye and author of the Mapp and Lucia novels. Some of these are famously set in Tilling, which is in fact Rye, and the house of Mallards is of course Lamb House. The world of Mapp and Lucia – like many parts of the south coast – is a world of people of 'good breeding and narrow incomes'; also of snobbishness and pretention, all deliciously and lovingly presented by Benson.

> Lucia seated herself by the sundial, all in black, on a stone bench on which was carved the motto 'Come thou north wind and come thou south, that my garden spices may flow forth.' Sitting there with Pepino's poems and The Times she obscured about one third of the text and fat little Daisy would obscure the rest...[2]

The widowed Lucia, as it happens, rather suits black. She knows this and so do the good people of Tilling.

E. F. Benson's brother, A. C. Benson, also stayed at Lamb House. He wrote supernatural stories and also provided the words for 'Land of Hope and Glory'. We do not know exactly where he penned the words. Since Blake wrote the revolutionary anthem in the far west of the county it would be very symmetrical if the imperial anthem had come from the far eastern end. Sadly, there is no evidence to support this.

Radclyffe Hall moved to Rye when her literary career was prospering in 1928. Noel Coward, a friend of Sheila Kaye-Smith, was living nearby and the little town was charming. Radclyffe Hall first moved into a house called Journey's End, which may not have been auspicious, and then to Black Boy House. Sadly, her career was torpedoed by an obscenity trial and her Rye-based novel *Hannah* was not a success.

Radclyffe Hall's house, Rye.

In the 1960s, Rumer Godden moved into Lamb House. Godden (1907–98) was born in Eastbourne and went off to live with her parents in India. She was sent back to England and attended Moira House School in Eastbourne. Godden lived in India for many years and set many of her works there. *Black Narcissus* was the most famous, perhaps because it was made into a film by Powell and Pressburger. The film was only loosely based on the book, and was set in the high passes of the Himalaya (actually Shepperton Studios and Leonardslee Gardens). The original book is set close to Darjeeling, where Rumer Godden spent some of the Second World War on a tea plantation called Rungli-Rungliot. In the novel a group of western nuns – from an order based in Sussex – attempt to bring their ideas of civilization to India and fail. The air is too clear, the wind is too constant, the mountains are too high and the local people simply will not fit in. Godden was one of the many authors who had links to India and to Sussex: Orwell, Leonard Woolf, M. M. Kaye and, of course, Rudyard Kipling, who lived 12 miles to the north.

Just outside Rye is the grid-patterned hill town of Winchelsea. This was favoured by artists and writers. Millais painted here, and Thackeray wrote about it in *Denis Duval*. Ford Madox (1893–1939) owned property in the town and lent one of his cottages to Joseph Conrad (1857–1924).

Winchelsea is now a small town on a hill, surrounded by flat marshy land. A few centuries ago it was a port – one of the so-called Cinque Ports, which defended the channel. Conrad and Ford Madox Ford collaborated on a history of these ports, published in 1900.

Ford Madox Ford's house in Winchelsea.

The cottages in Winchelsea – Conrad lived at No. 4.

The churchyard and the Glebe, Winchelsea.

8. The Call of the Weald

The High Weald

At the far north of the county, Sussex comes close to London, and has a distinctly modern air. There is Gatwick Airport, but only just as soon as an aircraft clears the runway, it is flying over Surrey. East Grinstead had a kind of modernity in the twentieth century, when it became the headquarters of the Church of Scientology. This drew the Gaiman family to the town when their son Neil was five years old: he later became a bestselling author of fantasy fiction and graphic novels.

A little south and east of these modern spots is the older and very different world of the High Weald. The High Weald has had a bad reputation for centuries: 'the deepest, dirtiest, but many ways the richest, and most profitable country in all that part of England', says Daniel Defoe.[1] 'Weald' is an Anglo-Saxon word for forest, and in the eighteenth century the high ground was known locally as 'The Wild'. Communications were difficult once the Roman roads had worn away. There were plenty of small roads here between the villages – there needed to be, as any individual road was likely to be impassable. The Sussex dialect has thirty words for mud, and most of them apply here. Where it is not

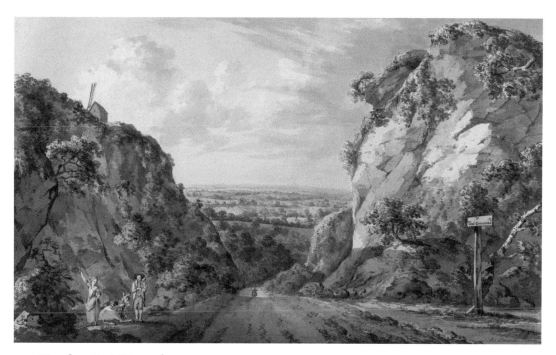

View from East Grinstead.

muddy – where it is in Arthur Young's phrase a 'Sandy Waste' – we have the Ashdown Forest, which Cobbett called 'a heath with here and there a few birch scrubs upon it, verily the most villainously ugly spot I ever saw in England'[2].

It is the High Weald that separated Sussex from London. Even in the 1800s one MP for Sussex would travel to the capital as fast as he could, making sure that he and his footmen were fully armed. Local documents from the time refer to the areas as 'The Wild'. In Anglo-Saxon times, this was the last part of England to become Christian, and through the Middle Ages it was famous for harbouring criminals and outcasts. It became, for a century or two, the industrial heartland of England. The streams here often run red because of the iron in the soil, and the area has plenty of wood and water. When the blast furnace was introduced here in 1490 the Weald became alive with industry, creating hammer ponds, felling trees, smelting iron and making guns. According to Camden: 'Many meadows are reduced into ponds and pools for the driving of mills by the flashes, which, beating with hammers upon the iron, fill the neighbourhood with noise, night and day.'[3]

It is hard to reconcile this with the quiet world of the Weald today. Kipling appreciated this, looking back to the days of the Armada.

> See you the dimpled track that runs
> All hollow through the wheat
> Oh that was where they hauled the guns
> That smote King Philip's fleet!
>
> *Puck of Pook's Hill*, Rudyard Kipling

Incidentally, the gunmakers of the Weald were not only supplying the English navy. Queen Elizabeth launched an investigation into the ironmasters. She had a fair idea of how many guns were being made and a very precise idea of how many she was buying. The remainder were clearly being sold over the Channel, with King Phillip of Spain especially eager to buy. It was not a world that encouraged literature and fine arts. There still survive from the early eighteenth-century letters from John Fuller, the Brightling ironmaster. The local vicar, James Hurdis (1763–1801), became a celebrated poet, and described one of the Fullers' workers:

> See, pale and hollow-eyed in his blue shirt
> Before the scorching furnace, reeking stands
> The weary smith. A thundering water-wheel
> Alternately uplifts his cumbrous pair
> Of roaring bellows. He torments the coal
> And stirs the melting ore...
>
> *The Village Curate*, James Hurdis

By the early twentieth century, communications made it possible to visit the area at the weekend. Rudyard Kipling, the laureate of the Empire, had his home in Burwash in the High Weald of Sussex. He had lived in Rottingdean, near Brighton, but found it too busy. In 1902 he bought a Jacobean manor house called Batemans and was the proud owner of a

substantial estate and an ancient mill. Kipling loved being part of this ancient agricultural Sussex. He followed the publications of the Sussex Archaeological Society, and in 1906 he published the set of children's stories, *Puck of Pook's Hill*. These trace the history of England via the history of Sussex, from Roman times and through the Anglo-Saxon and Norman invasions.

Kipling was fascinated by William Isted, a local hedger, ditcher and poacher. In *Puck of Pook's Hill* (1906) there is an earthy character, 'old Hobden the hedger', whose long line of ancestors has worked this land since Roman times.

Just before Christmas 1913 Kipling attended a feast for local men on his estate.[4] William Isted was there, along with a fine collection of Old Hobden's degenerate relatives. At the dinner table, there were sixteen men including Weekes ('a blackguard'), Jabiz Petit ('senile emptier of earth-closets') and young Hicks ('an inadequate bricklayer's assistant'.) The evening began a little uneasily, but it soon loosened up: the workers drank at least a gallon of beer each, and one individual had four servings of roast beef. The beer was followed by Christmas pudding in brandy and the locals were soon feeling the effects of the drink. As the evening ended, two of the revellers staggered home supporting each other and trying to sing 'When Shepherds watched' but lost both the words and the tune.

Kipling drank little, of course, but observed the evening closely. He paid attention to the songs the men sang during the evening. Singing in public was normal in those days, and young Hicks often sang at The Rose & Crown. One man sang 'I Never Interfere', an American song from the 1870s. Another man sang a sentimental ditty, 'Annie Dear,

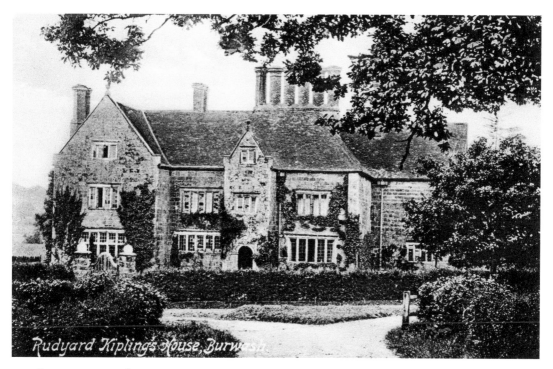

Batemans postcard.

I'm Called Away', about a soldier who is 'called away' to fight for his country, then 'called away' even further when he is killed. There were songs about men leaving their girls at home. Hicks sang about a young soldier dying among the 'burning sands of Egypt'. There is no mention here of traditional Sussex folksong and no mention of the Sussex high-pitched and erratic singing style. The singing style and the songs that evening were both from the jingoistic music hall. If Kipling noticed this, he did not remark on it.

At the same time, just 15 miles to the west, at Coleman's Hatch, William Butler Yeats was hard at work, humming to himself. He first began to rent Stone Cottage in November 1913, a small house on the edge of Ashdown Forest. 'Forest' here is used in the old sense: it is heathland once used for deer hunts. Yeats came here to find solitude, although a nearby house called The Prelude was occasionally occupied by Dorothy Shakespear, the Vorticist painter. Yeats never met Kipling. They were both eminent writers – Kipling was the first Englishman to win the Nobel Prize for literature (1907) and Yeats would be the first Irish winner (1922). However, there was a world of difference, political and poetic, between Kipling's *Ulster 1912* and Yeats's *Easter 1916*.

The isolation of Stone Cottage suited Yeats, and he set about writing poetry. His housekeeper recalls that she had to stay quiet when Mr Yeats was at his desk humming. Yeats was accompanied by his American secretary, the much younger Ezra Pound. Pound was penniless at the time and pleased to have somewhere to live, where Mrs Welfare the housekeeper provided good hot food. In later years, caged by the US Army in Pisa,

Rudyard Kipling by William Strang. (National Gallery of Art, The Rosenwald Collection)

he would fondly recall his time here. In December 1913, the coming realities of the new century – world wars, the Easter Rising and Mussolini – were unimaginable. The two poets were wholly lost in their work. Yeats walked down to the village post office one morning and came back exasperated that it was shut. He was not aware that it was Christmas Day.

Ashdown Forest was despised in the eighteenth and early nineteenth centuries, but popular sentiment has mellowed since then. Yeats was advised not to get lost in the woods, which were weird and 'possibly faerie'. Visible from Stone Cottage there were some tall pine trees that had been stripped of all their lower branches. These were noted by Dorothy Shakespear and later became famous in the drawings of Ernest Shepard. Stone Cottage was very close to Five Hundred Acre Wood where, a few years later, Christopher Robin and Winnie the Pooh had their adventures, as recorded by A. A. Milne. Milne, incidentally, saw himself as a playwright rather than a children's author.

To the south-east of the country is the land that Sheila Kay-Smith (1887–1956) turned into a region as distinctive as Hardy's Wessex. Like other 'regional' novelists of the time, she can build a story up from the landscape. It is an isolated and complete world, where characters seem to have grown from the soil. A typical novel is *Sussex Gorse: The Story of a Fight* (1924). This is not widely read now, so a summary is in order.

Poohsticks Bridge near A. A. Milne's house.

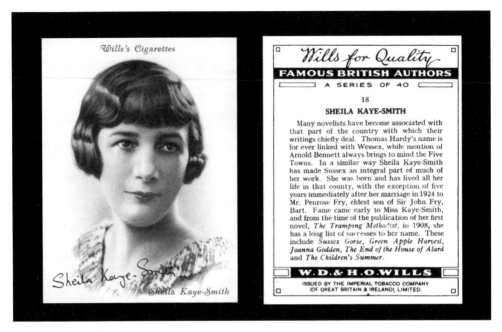

Sheila Kaye-Smith.

Growing up near Peasmarsh, the young Reuben Backfield opposes the enclosure of Boarzell Moor and is sentenced to flogging. He is appalled that his father, who could be so weak, allowed this to happen. The land in question is a few hundred acres of unyielding Sussex heathland. Reuben is determined to acquire it, work it and make it his own. This over the course of his life he does. As soon as his father dies, he sacks the servants and uses his mother as a servant. His brother is blinded and deranged by an explosion and is set to work as a blind fiddler, all proceeds going to Reuben. Reuben has had his eye on his brother's fiancée for some time and takes the opportunity to marry her. She has a substantial dowry and will bear sons. Daughters are not required, and Reuben is not bothered when one of them dies. When his own mother dies after a period of illness, he is slightly relieved: she had not been profitable for several months.

This goes on for decades, as Reuben destroys his children's lives. The author has a deep knowledge of farming techniques and the importance of the outside world, but her real passion is Reuben. He is strong and has a touch of Heathcliffe. His brother's fiancée 'was afraid of Reuben, she fled before him like a poor little lamb, trembling and bleating—and yet she would sometimes long for the inevitable day when he would grasp her and fling her across his shoulders'.[5]

This comes close to self-parody, and on top of this, the characters sometimes speak in a heavy Sussex dialect, always a treacherous path for a printed book.

Now you're not to go quarrelling wud him, Harry. I'd sooner have peace than anything whatsumdever. I äun't used to being set agäunst people. Besides, it wöan't be fur long.[6]

Ashdown Forest.

Kaye-Smith was famous in her time, and some of her novels became successful films including *The Loves of Joanna Godden*. Sadly, for her reputation, one of her contemporary readers was Stella Gibbons (1902–89). Gibbons had acquired a reputation as a caustic book reviewer, and especially enjoyed tearing at the earth-bound novels of rural passion. In 1932 Gibbons published the satire *Cold Comfort Farm*. It is the story of the Starkadders, a Sussex family riddled with dark secrets and brooding ambitions. They live in the fictional village of Howling, where the local pub is called The Condemned Man, and they are drawn to the hellfire religion of the Quivering Brethren. The regional novel never quite recovered.

Copsford

Between Horam and Waldron, there are coarse meadows and small copses, and a surprising silence. It was here, just after the First World War, that Walter Murray came to live. Murray (1900–85) was born in Seaford, son of a churchman with literary aspirations. He went to work as a freelance journalist and was living in a noisy apartment close to Victoria Station when he decided to seek rural peace. Since he had so little money, that peace also meant isolation. He knew about a peculiarly lonely cottage, only a mile from the nearest lane or farm, but that mile was across rough and open countryside. There was no track remaining, and the cottage was bordered on one side by a deep brook, known as the Darn. The cottage was in a copse, close to the summit of a hill, so that passers-by kept their distance.

To reach it, in those interwar years, you would take the train from London and stop at a station called 'Horeham Street for Waldron'. From there, a half hour's walk towards Waldron would lead you to the ruin where, for a year, Murray lived rather as Henry Thoreau

had done at Walden Pond. The cottage – rat-infested and without running water – was all that was left of a farmstead called Copsford. Murray fought off the rats with the aid of his dog, bathed in the brook and blocked the window frames with cardboard. There is a touch of Robinson Crusoe here: he creates makeshift solutions with the materials to hand. He can bathe in the brook because he has found a piece of corrugated iron to cover the slippery mud on the water's edge. To make ends meet, the author began to collect wild herbs, dried them and sold them to a dealer. It was not a way to get rich quickly (or slowly for that matter) but it provided a purpose and order. One day, Murray 'saw a shaft of sunlight fill a spring-green copse till it glowed as the glory of the Light of the World dwelled within...'[7]

Murray married and settled in Horam. He published three books, one of them *Copsford* (1948) – based upon his notes from his stay. He set up a coeducational school and became a stalwart of the local community. He was aware that things pass.

> The barn and byres which had been the Copsford farm buildings had already disintegrated. In another twenty years' time there would be no recognisable trace; grass and weeds, rushes and brambles will have clothes and hidden them completely. Another fifty years, say, and, left alone, Copsford Cottage will have disappeared likewise.[8]

As indeed it has. At the site of the house – if you seek it out – you can find a scattering of bricks and a small square of concrete.

Copsford today.

The Pevensey Levels and Herstmonceux

On the coast 10 miles south of Copsford is Pevensey Castle, an old Roman fort that was once on a peninsula but which is now surrounded by the flat marshlands of the Pevensey Levels. It attracted visitors from Eastbourne as soon as the railways arrived. T. S. Eliot and Lewis Carroll each made the trip from Eastbourne out to the ruins. On 18 September 1880, Richard Jefferies visited Pevensey Castle and had an illumination. By the ancient stones of the Roman fort he encountered a sense that he had been existing since Roman times, and saw his whole life reflected back at him. The literary result of this revelation was what Edward Carpenter called 'the imperishably beautiful book', *The Story of My Heart* (1893). Jefferies lived in Sussex for many years and wrote about the county. *The Story of My Heart* was about something larger: the universe and our place in it. Jefferies is little read now, but was greatly admired by Henry Miller, Henry Williamson (author of *Tarka the Otter*) and Rachel Carson (author of *Silent Spring*). Edward Thomas wrote a biography of Jefferies, and W. H. Hudson was eager to live in his old house in Goring.

As always in Sussex, this area has its Indian connections. In Boreham Street there is the house of M. M. Kaye (1908–2004), said to be a distant relation of Sheila Kaye-Smith. M. M. Kaye lived in India for much of her life, as her husband was an officer in the Indian Army. When he retired, they went to live in Boreham Street and she spent twelve years writing her best-selling novel, *The Far Pavilions*.

Pevensey Castle.

Boreham Street, with M. M. Kaye's house.

A little north of the marshes, the Weald begins and so does religious nonconformity. The rich farmlands of the Sussex plain favoured religious orthodoxy. A labourer in a tied cottage on a big estate would be wise to attend the Church of England on a Sunday morning. Up in the Weald, things were different, and there are small Nonconformist chapels by the country roadsides. One of these helped produce a modern masterpiece.

Dorothy Richardson (1873–1957) might be the forgotten great of modern writing. In *Pointed Roofs* (1915) she introduced an indirect style, attempting to capture the life of the heroine Miriam Henderson. A reviewer of 1918 adopted a new phrase to describe her writing: 'stream of consciousness'. That phrase – which Richardson hated – came from the psychologist William James, Henry's brother and a visitor to Rye. Richardson insisted that she was trying to represent reality, and that reality did not easily conform to beginnings and middles and ends, or indeed to punctuation. Specifically, she felt that feminine reality was not to be encompassed by masculine grammar.

Pointed Roofs was the first of a series of 'chapters' in a grand novel called *Pilgrimage*, a semi-autobiographical work.

She had been working as a dentist's receptionist in London, but became pregnant thanks to H. G. Wells, who soon married a schoolfriend of hers. The pregnancy ended in a miscarriage, and at a low point in her life, aged thirty-four, she went to live with the

Dorothy Richardson.

Penrose family, Quakers who ran the market garden at Mount Pleasant at Windmill Hill. She had produced some journalism over the previous years, but in Windmill Hill she began to produce short sketches of life, which she called 'middles', pieces which had no clear beginning or end.

The first of these was 'A Sussex Auction', a 1908 sketch that tells us little about the auction itself: 'The passage of the clouds across the wide sky, the pageant of the afternoon-light, the flight of birds over the rolling meadow-land, the kindly grey downs in the distance are all unnoticed. Except perhaps by the girls who hover round the margin of the moving group. But they too are in bondage.'[9] Richardson produced many of these sketches, and did not expect to make a living from them.

Her first published book was the factual *The Quakers Past and Present* in 1914. *Pointed Roofs* followed in 1915, the start of the cycle of autobiographical works. This occupied her for much of her life, slowly recounting her autobiography in successive volumes. In *Dimple Hill* (1938) she describes how Miriam, desolated by her life in London, moves down to Sussex and lives with a family of Quakers. At least she discovers a route to peace.

Wealth, not to be finding rain unwelcome. Not to care if it rained for days. To be revelling in the sound of 'awful weather.' Hitherto, rain, or even the threat of it, had been the sworn enemy of holiday, a cruel intruder banishing enchantment, leaving one

exposed to awareness of the swift passing of allotted days, the ruthless approach of their impossible end. Last week, down on the coast, it had become for the first time a challenge to adventure. To-day, it was blessed exemption from seeing and doing. Descent, laden with treasure one could afford to forget, down into impersonality where past and future, vanished from their places, lay powerless to nudge and jostle, far away within the depths of a perfect present.[10]

In the silence at the modest Friends Meeting House, the heroine finds a new way of being in the world. 'To remain always centred. Operating one's life operating even its wildest enthusiasms from where everything fell into proportion and clear focus.'[11] The old Meeting House in Herstmonceux is still standing.

Life among the Quakers is not perfect. Rachel Mary, a Quaker girl, gives up her life in performing small services for her brothers so that they can do the bigger things in life. She loves music, but for most of her life music has been banned as sinful. As she looks towards Pevensey across the flat marshland, she has a dismal premonition of her uneventful future.

Friends Meeting House in Herstmonceux.

9. The Sussex Writers

Many of the authors discussed in this book are now lost, probably for good: James Hurdis of Burwash, Edward Shanks of Rodmell and William Hayley of Felpham. Some popular writers, like Hammond Innes of Horsham, are almost gone. The process can be very swift. At the end of the last century, Catherine Cookson was, for seventeen years running, the most-borrowed author in English libraries. Then in 2006 she disappeared from the top ten. By 2011 she was not in the top 250.

Alice Meynell, writing in August 1915, explained just how many writers were visiting her house in Greatham. A bomb falling there would deprive the world of so many literary figures: Shane Leslie, who was beginning a novel, Gladys Parrish, Viola Meynell and the successful Victoria Hawtrey. Alice also mentions the presence of 'a certain Mr Lawrence'.[1] David Herbert Lawrence was at Greatham, finishing *The Rainbow* and preparing a cruel satire on the Meynell family in *England, My England*. His works are still in print. The names of Alice, Viola, Shane, Gladys and Victoria might perhaps be known to some literary historians.

Sheila Kaye-Smith, the almost forgotten author of Sussex family sagas, once reflected on literary reputations. She remembered a Matilda Betham-Edwards of Hastings, whose novel *The White House by the Sea* was published in the World's Classics series. Ms Betham-Edwards felt secure in her immortality. In Eastbourne, two churches memorialised the works of Edna Lyall, the town's most successful novelist – John Ruskin had one of her novels by his bed when he died. If we have not read the works of Matilda Betham-Edwards or Edna Lyall, we should not comment.

Kaye-Smith raised some interesting questions about literary fame. In particular, she noted back in 1955 that there was a new factor in literary reputation. Both *Animal Farm* and *1984* had made their reputations on the basis of cinema. Sheila Kaye-Smith was herself still well known at this time, partly because of the film adaptation of *Joanna Godden*, but the film industry has not saved her reputation. Nor did it save Tickner Edwardes of Burpham, whose novel *Tansy* was made into a feature film in 1921.

Reputations can rise and fall. In 1952, Elizabeth Robins of No. 24 Montpellier Crescent, Brighton, ('authoress of *Raymond and I* and *The Magnetic North*', according to the local paper) died and left a manuscript in her will. The newspaper reported this with the headline: 'Left MS of Book to Rodmell Man'.[2] Now Elizabeth Robins is forgotten but the Rodmell Man published a set of autobiographies and is remembered, even in rural Sussex, as Leonard Woolf the writer. This may change again: Elizabeth Robins was a successful novelist in her time and brought *Hedda Gabler* to the London stage. Her feminist 1907 play *Votes for Women* has been revived recently. Elizabeth Robins might once more be as famous as Leonard Woolf.

Elizabeth Robins. (Library of Congress, Bain News Service)

In 1864 a newspaper described Blake's cottage in Felpham as 'a thatched house, one room deep with only six rooms, close to the sea but still protected from the genteel resort of Bognor'. Blake himself, according to the article, had become old fashioned and was doomed to oblivion:

> Few men of the present day remember who William Blake was. In these railroad days, his fervid powers ... would meet very little acceptance from the dealers or the picture brokers.[2]

The following list of Sussex writers is therefore offered as purely provisional.

Jane Austen (1775–1817) Worthing
Edith Bagnold (1889–1981) Rottingdean
Hilaire Belloc (1870–1953) Slindon, Shipley
E. F. Benson (1867–1940) Rye
William Blake (1757–1827) Felpham
Andrew Boorde (1490–1549) Chichester, Pevensey
Dirk Bogarde (1921–99) Lullington
Wilfred Scawen Blunt (1840–1922) Petworth

Julie Burchill (b. 1959) Brighton
Fanny Burney (1752–1840) Brighton, Lewes
Thomas Carlyle (1795–1881) Hastings
Ivy Compton-Burnett (1884–1969) Hove
Lewis Carroll (1832–98) Eastbourne, Hastings
William Collins (1721–59) Chichester
Cressida Connolly (b. 1960) Eastbourne
Cyril Connolly (1903–74) Eastbourne
Joseph Conrad (1857–1924) Winchelsea
Stephen Crane (1871–1900) Brede
Arthur Conan Doyle (1859–1930) Crowborough
Maureen Duffy (b. 1933) Worthing
Ticker Edwards (1865–1944) Burpham
John Fletcher (1579–1625) Rye
Christopher Fry (1907–2005)
Neil Gaiman (b. 1960) East Grinstead
John Galsworthy (1867–1933), Nobel Laureate 1932, Bury
Rumer Godden (1907–98) Eastbourne, Rye
Graham Greene (1904–91) Brighton
Rider Haggard (1856–1925) Hastings
Radcliffe Hall (1880–1943) Rye
Patrick Hamilton (1904–63) Hove
David Hare (b. 1947) Bexhill
William Hayley (1745–1820) Eartham, Felpham
Henry James (1853–1916) Rye
Peter James (b. 1948) Brighton
Richard Jefferies (1848–87) Crowborough, Pevensey
M. M. Kaye (1908–2004) Boreham Street
Sheila Kaye-Smith (1887–1956) Hastings, Peasmarsh
John Keats (1795–1821) Chichester
John Maynard Keynes (1883–1946), Tilton House
Rudyard Kipling (1865–1936), Nobel Laureate 1907, Rottingdean, Burwash
D. H. Lawrence (1885–1930) Greatham
A. A. Milne (1882–1956) Ashdown Forest
George Meek (1868–1921) Eastbourne
Kate Mosse (b. 1960) Chichester
Walter Murray (1900–85) Horam
Amelia Opie (1769–1853) Felpham
Thomas Otway (1652–85)
Coventry Patmore (1823–1896) Hastings
Mervyn Peake (1911–68) Wepham
Harold Pinter (1930–2008) Worthing
Ezra Pound (1885–1972) Coleman's Hatch

John Cowper Powys (1872–1963) Burpham
Arkartdamkeung Rapheephat (1905–32) Bexhill
Dorothy Richardson (1873–1957) Herstmonceux
Elizabeth Robins (1862–1952) Brighton
Thomas Sackville (1536–1608) Buckhurst
Percy Shelley (1792–1822) Horsham
Charlotte Smith (1749–1806) Bignor Park
Rosemary Sutcliffe (1920–92) Walberton
W. M. Thackeray (1811–63) Brighton, Winchelsea
Edward Thomas (1878–1917) Sussex
Robert Tressell (1870–1911) Hastings
Ted Walker (1934–2004) Lancing
Keith Waterhouse (1929–2009) Brighton
H. G. Wells (1866–1946) Uppark House
Angus Wilson (1913–91) Bexhill
Virginia Woolf (1882–1941) Rodmell, Firle, Southease
Leonard Woolf (1880–1969) Rodmell, Southease
W. B. Yeats (1865–1939), Nobel Laureate 1923, Coleman's Hatch
Helen Zahavi (b. 1966) Brighton

Endnotes

Introduction
1. Walpole, Horace, Letter to George Montague, 26 August 1749

Chapter 1
1. *The Quarterly Review* (London, 1825), p. 289
2. Keynes, Geoffrey, *The Letters of William Blake* (London: MacMillan, 1956), p. 50
3. Keynes, Geoffrey, *The Letters of William Blake* (London: MacMillan, 1956), p. 51
4. Gilbert White. *The Natural History of Selborne* (London, 1789) p. 15
5. Keynes, Geoffrey, *The Letters of William Blake* (London: MacMillan, 1956), p. 78
6. Davis, John, *The Origin and Description of Bognor or Hothampton* (London, 1807), p. 95
7. Smith, Charlotte, *The Young Philosopher* (University of Kentucky, 2015), p. 7
8. Lucas, E. V., *Highways and Byways in Sussex* (London: Macmillan, 1904), p. 63
9. Austen Jane, *Sanditon* (Boston: Houghton Mifflin, 1975), p.6
10. Austen Jane, *Sanditon* (Boston: Houghton Mifflin, 1975), p. 5
11. Austen Jane, *Sanditon* (Boston: Houghton Mifflin, 1975), p. 16
12. Wright, Charles, *The History and Description of Arundel Castle* (London, 1818), p. 167

Chapter 2
1. Belloc, Hilaire, *The Four Men: A Farrago* (London: Nelson, 1911), p. ix
2. Belloc, Hilaire, *Ha'naker Hill* (London: Nelson, 1911), p. ix

Chapter 3
1. Burney, Fanny, *Diary and Letters of Madame d'Arblay* (London, 1842), p. 212
2. Burney, Fanny, *Journals and Letters* (London: Penguin Books, 2006), 29 May 1779
3. Austen, Jane, *Pride and Prejudice* (London, 1813), chapter 41
4. Gray, Fred, *Designing the Seaside* (London: Raktion, 2006), p. 82
5. Burchill, Julie, *Sugar Rush* (London: Macmillan, 2016), p. 2
6. Greene, Graham, *Brighton Rock* (London: Heinemann, 1970), p. 17
7. Greene, Graham, *Brighton Rock* (London: Heinemann, 1970), p. 263
8. Waterhouse, Keith, *London by the Sea* in *Waterhouse at Large* (1987), p. 343
9. Waterhouse, Keith, *Palace Pier* (London: Hachette, 2003)
10. Truss, Lynn, *A Shot in the Dark* (London: Raven, 2018), p. 2
11. Compton-Burnett, I., *A Father and His Fate* (London: Gollancz, 1957), p. 9
12. Stape, J., *Virginia Woolf Interviews and Recollections* (London: Macmillan, 1995)

Chapter 4

1. Galsworthy, John, *To Let* (London: Heinemann, 1921), chapter 8
2. Wells, H. G., *Tono Bungay* (London, 1908), chapter 1
3. Wells, H. G. *The Time Machine* (London, 1895), chapter 8
4. Wells, H.G.,*The Time Machine* (London, 1895), chapter 8

Chapter 5

1. Gissing, George, *Thyrza* (London 1887), chapter 29
2. Meek, George, *George Meek: Bath Chair-man* (London: Constable, 1910), p. 174
3. Gissing, George, *Thyrza* (London, 1887), chapter 2
4. Carlyle, Thomas, quoted in Burdet, Oscar, *The Two Carlyles* (New York: Haskell, 1971), p. 265
5. Tressell, Robert, *The Ragged Trousered Philanthropists* (London, 1914), chapter 41
6. Tressell, Robert, *The Ragged Trousered Philanthropists* (London, 1914), chapter 36
7. *Eastbourne Gazette*, 21 March 1951

Chapter 6

1. Richard Jefferies, *The Breeze on Beachy Head* (London, 1881)
2. Lucas, E. V., *Highways and Byways in Sussex* (London: Macmillan, 1904), p. 63
3. Harris, Alexandra, *Weatherland* (London: Thames and Hudson, 2015), p.7
4. Bogarde, Dirk, *A Postillion Struck by Lighting* (London: Chatto and WIndus, 1979), p. 114
5. Woolf, Virginia, *Evening Over Sussex* in *Essays of Virginia Woolf* Vol VI (London: Chatto and WIndus, 2017)
6. Woolf, Virginia, *Diaries of Virginia Woolf* Vol 3 (London: Hogarth Press, 1980), p. 198
7. Shanks, Edward, *The People of the Ruins* (London, 1920), chapter 2
8. Bagnold, Edith, in Stape, J., *Virginia Woolf Interviews and Recollections* (London: Macmillan, 1995)
9. Evelyn, John, *Acetaria* (New York, Brooklyn Botanic Garden, 1937), p. 89

Chapter 7

1. James, Henry, *The Turn of the Screw* (London, 1898), introduction
2. Benson, E. F., *Mapp and Lucia* (London, 1931), chapter 1

Chapter 8

1. Defoe, Daniel, *A Tour Through the Whole Island of Great Britain* (London: Dent, 1962), p. 128
2. Cobbett, William, *Weekly Register* Vol 41 (London, 1822), p. 156
3. Camden, William, *Britannia* (Abridged) (London: Wild, 1701), p. 226
4. Kipling, Rudyard, *Letters of RK 1911–1919* (University of Iowa Press, 1990), p. 215
5. Kaye-Smith, Sheila, *Sussex Gorse: The Story of a Fight* (New York: Knopf, 1916), p. 2
6. Kaye-Smith, Sheila, *Sussex Gorse: The Story of a Fight* (New York: Knopf, 1916), p. 33
7. Murray, Walter, *Copsford* (London: Harper Collins, 1986), pp 83–84

8. Murray, Walter, *Copsford* (London: Harper Collins, 1986), p. 162
9. Richardson, Dorothy, *Dimple Hill* (London: Dent, 1938), p. 455
10. Richardson, Dorothy, *Dimple Hill* (London: Dent, 1938), p. 498
11. Richardson, Dorothy, *Dimple Hill* (London: Dent, 1938), p. 454

Chapter 9

1. Atkinson Damian, *The Selected Letters of Alice Meynell* (Cambridge Scholars, 2014), p. 370
2. *Dorset County Chronicle*, 21 April 1864

Further Reading

Belloc, Hilaire, *The Four Men: A Farrago* (1911)
Brandon, Peter, *Sussex* (2004)
Connolly, Cressida, *After the Party* (2018)
Greene, Graham, *Brighton Rock* (1938)
James, Peter, *Need You Dead* (2017)
Mosse, Kate, *The Mistletoe Bride* (2013)
Richardson, Dorothy, *Dimple Hill* (1938)
Kaye-Smith, Sheila, *Sussex Gorse: The Story of a Fight* (1916)
Tressell, Robert, *The Ragged Trousered Philanthropists* (1914)
Wilkinson, Walter, *A Sussex Peep-Show* (1933)

Further Watching

Brighton Rock, Boulting (1948) (Brighton)
The Punch and Judy Man, Summers (1963) (Bognor Regis)
Lobsters, Moholy-Nagy (1936) (Littlehampton)
Tansy, Hepworth (1921) (The South Downs)
Black Narcissus, Powell and Pressburger (1947) (Leonardslee Gardens)